Time & Bits

Managing Digital Continuity

MARGARET MACLEAN AND BEN H. DAVIS

EDITORS

Getty Conservation Institute
Getty Information Institute
The Long Now Foundation

The J. Paul Getty Trust
Los Angeles, CA 90049-1681
©1998 The J. Paul Getty Trust
All rights reserved.
Published 1998
Printed in the United States of America

05 04 03 02 01 5 4 3 2 1

Library of Congress
Cataloging-in-Publications Data

Time & bits ; managing digital
continuity / Margaret MacLean and
Ben H. Davis, editors.
 p. cm.
 Based on a project sponsored by
the Getty Conservation Institute,
the Getty Information Institute, and
the Long Now Foundation.
 Reprint of 1998 ed.
 Includes bibliographic references
(p.).
 ISBN 0-89236-583-8 (paperback)
 1. Computer files—Conservation
and restoration—Congresses.
2. Digital preservation—Congresses.
I. Title: Time and bits. II. MacLean,
Margaret. III. Davis, Ben H. IV. Getty
Conservation Institute. V. Getty
Information Institute. VI. Long Now
Foundation.

Z701.3.C65 T56 1999
025.8'4—dc21 99-046692

Contents

Foreword

The Getty is an organization committed to the arts and humanities, and to their understanding and appreciation by this and succeeding generations. It is part of our mission to protect the artistic and cultural legacy entrusted to all societies. We take seriously the notion of long-term responsibility in the protection of important cultural information, which in many cases now is recorded only in digital formats. The technology that enables digital conversion and access is a marvel that is evolving at lightning speed. Lagging far behind, however, are the means by which the digital legacy will be preserved over the long term.

As the reader will see, the initiative described in this report connected the Getty Conservation Institute and Information Institute and The Long Now Foundation with pioneers from industry, entertainment, and digital enterprise to focus on the task of preserving the content and meaning of these records. In the process, they came face-to-face with the potential loss of the record of the late 20th century because of a failure to think creatively and courageously about 21st-century challenges.

We are proud to join with this group of visionaries to advocate for the preservation of our artistic and cultural heritage, and to promote the discussion and resolution of these challenges. We intend to encourage and engage in many efforts that connect us with the communities that share our dedication to education, aesthetic appreciation, information exchange, and protection of our common inheritance.

Barry Munitz
President and Chief Executive Officer
The J. Paul Getty Trust

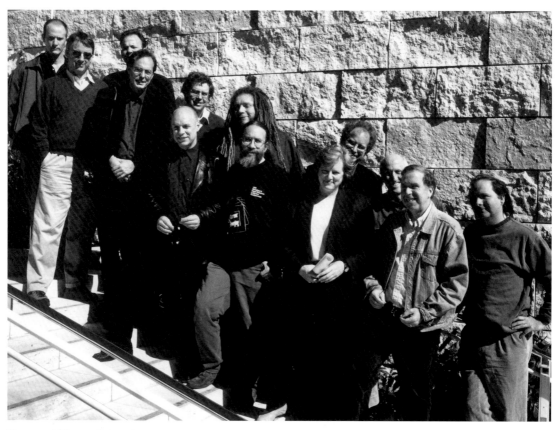

Time and Bits *participants:*
Alexander Rose, Peter Lyman, John Heilmann, Ben Davis, Brian Eno, Doug Carlston, Jaron Lanier, Howard Besser, Margaret MacLean, Brewster Kahle, Stewart Brand, Kevin Kelly, Danny Hillis

Cover design: Janice Kash
Photos: Gregg Mancuso,
Steven Swimmer, Ben H. Davis,
Cindy Anderson
Drawings: Alexander Rose,
Kevin Kelly, Brian Eno

We thank and acknowledge the following people for their contributions to this project:

Harold M. Williams, President Emeritus, The J. Paul Getty Trust
Miguel Angel Corzo, Director, The Getty Conservation Institute
Eleanor Fink, Director, The Getty Information Institute
Terry Sanders, Filmmaker, Sanders and Mock Productions
Alexander Rose, Executive Director, The Long Now Foundation
Shelley Z. Taylor, Consultant
Martin Diekhoff, The Getty Information Institute
Steven Swimmer, The Getty Information Institute
Janice Kash, The Getty Information Institute
Angela Escobar, The Getty Conservation Institute
Melena Gergen, The Getty Conservation Institute

Mapping the Project,
Grasping the Consequences

Ben Davis and Margaret MacLean

*This was a very unhappy interface. And small wonder. No
doubt this entire virtual environment was being encrypted,
decrypted, reencrypted, anonymously routed through satellites
and cables, emulated on alien machinery through ill-fitting,
out-of-date protocols, then displayed through long-dead
graphics standards. Dismembered, piped, compressed, pack-
eted, unpacketed, decompressed, unpiped and re-membered.
Worse yet, the place was old. Virtual buildings didn't age like
physical ones, but they aged in subtle pathways of arcane
decline, in much the way that their owners did. A little bijou
table in the corner had a pronounced case of bit-rot: from a
certain angle it lost all surface tint.*

Bruce Sterling, *Holy Fire*[1]

Bruce Sterling is a journalist and science fiction author who
founded and manages the Dead Media Project, an Internet mail-
ing list about extinct forms of human communication. He was to
attend the conference at the Getty Center that is described in this
report, but could not, and he was missed.

In this vivid scenario from his most recent book, he comments
darkly on the heroine's attempt to interact with a virtual environ-
ment that had been rendered unintelligible by obsolete technol-
ogy. The power of this novel resonates with the situation in which
we find ourselves right now: the end of the most materially
obsessed century in history is characterized by a ubiquitous tech-
nology that produces ephemera.

The fact is, computers solve many problems, but they create
new ones. Around the world, decisions are being made to commit
cultural memory to digital technology—and marking time with
bits—under the assumption that someone, somewhere, is taking
care of the details. What we are discovering is that "someone,
somewhere" is not there. Not yet. Representing the Getty,
through its Conservation and Information Institutes, we [Davis,
MacLean] saw not just an opportunity, but a responsibility to
make this fact known to our constituencies so that they could
make informed decisions about their use of digital technology.

1

When I was a kid,

growing up in the 1960s,

people thought

of the future

as the year 2000.

And now it's 1998

and people still

think of the future

as being the year 2000.

It's like the future

has been shrinking

one year per year

for my entire life.

DANNY HILLIS

The mission of the Getty Conservation Institute is to further the appreciation and preservation of the world's cultural heritage. As part of its commitment to enhance the philosophy and practice of conservation, the Institute undertakes research and applied projects, shares its knowledge base worldwide, and collaborates with partners to promote an informed awareness of and involvement in safeguarding the world's cultural heritage. Within this context, we recognize the importance of providing sound guidance—when asked—about the means by which governments, organizations, and other authorities might best protect their own heritage.

The mission of the Getty Information Institute is to strengthen the presence, quality, and accessibility of cultural heritage information through global networks. The Communications Program of the Information Institute is focused on digital publication, digital design, and digital distribution. Inherent in those activities is the concern about how long what is produced digitally will last. And if we are committing cultural memory to digital technology, what risks are we taking?

Many communities are concerned with the longevity of digital materials, as you will see in this summation of the "Time and Bits: Managing Digital Continuity" project, that culminated in a meeting held at the Getty Center in February 1998. Among them, the library and archives constituency in particular has been making considerable progress in publicizing the issues. For this reason, we commissioned two of its luminaries—Howard Besser and Peter Lyman—to summarize where we are and how we got here, included as part of this report.

We also recognized that ensuring the survival of digitally recorded information—especially cultural information—would require the involvement of many groups, professions, businesses, and non-profit organizations. Indeed, it will take real cooperation and collaboration among these communities, a first for some of them.

It might be helpful to identify the focus of the discussions within the context of the larger array of information management issues that are such a challenge for so many of us. The revolution of digital information technologies has made it possible to ask and answer two questions that until now have seemed ludicrous: Is it possible to quantify the aggregate of all human information? And is it possible to save it digitally? Michael Lesk contributed a paper to the Time and Bits Web site before the meeting [since then noted physicist Philip Morrison has written a compelling article for *Scientific American* based on the paper (July 1998)] that asks and answers these very questions in digital terms. Lesk's conclusion is

that "soon after the year 2000 the production of disks and tapes will outrun human production of information to put on them." In other words, technically speaking, you could save everything. But how long would it last? And who or what decides to save it all? Given what we all know of political reality, both the possibility and the wisdom of having a central authority in charge of deciding what gets saved are inconceivable.

In their landmark report,[2] the Task Force on Archiving of Digital Information provided an analysis of the digital landscape, focusing on features, including stakeholder interests, that affect the integrity of digital information objects and which determine the ability of digital archives to preserve such objects over the long term. The Task Force then introduces the principle that responsibility for archiving rests initially with the creator or owner of the information and that digital archives may invoke a fail-safe mechanism to protect culturally valuable information.

During the panel discussion, participant Brian Eno spoke of the possibility that without some general standards and rules, society might end up saving that which is easiest to save. Communities will need to decide what is valuable to them. What they need are methods to do so, with likely attention to three main kinds of documents [text, images, whatever] in ascending order of complexity . . .

- ▮ Simple documents whose original form could be in bits or atoms;
- ▮ Interactive documents that started out in digital form, whose purpose includes their connectedness to other documents, media, or server locations;
- ▮ Documents created in atoms whose original version is precious; and/or that have, over time, accrued annotations, additions, smudges, strike-throughs, and other evidence of use and significance.

So, this project centers largely on mapping the problem. In approaching any problem, one can begin by dividing it in three parts: causes, consequences, and solutions. In this situation, the consequences are the clearest of the three. Discussions of causes and solutions are found later on in the report.

Consequences of the Problem

Deanna Marcum, President of the Council on Library and Information Resources, has observed that when a culture loses its memory,

it loses its identity. In a letter to the editor of *The Washington Post* in January 1998, she explained "The Greater Digital Crisis" :

> We run the risk that digital information will disappear. Indeed, portions of it already have become inaccessible. Either the media on which the information is stored are disintegrating, or the computer hardware and software needed to retrieve it from obsolete digital formats no longer exist. The extent of the problem will emerge as more and more records are requested for retrieval and cannot be read. There are already documented examples of this [. . .].
>
> Military files, including POW and MIA data from the Vietnam War, were nearly lost forever because of errors and omissions contained in the original digital records. Ten to twenty percent of vital data tapes from the Viking Mars mission have significant errors, because magnetic tape is too susceptible to degradation to serve as an archival storage medium.
>
> Research conducted by the National Media Lab [. . .] has shown that magnetic tapes, disks and optical CD-ROMs have relatively short lives and, therefore, questionable value as preservation media. The findings reveal that, at room temperature, top-quality data VHS tape becomes unreliable after 10 years, and average-quality CD-ROMs are unreliable after only five years. Compare those figures with a life of more than 100 years for archival-quality microfilm and paper. Current digital media are plainly unacceptable for long-term preservation.
>
> Finding a late-model computer to read a 5¼-inch floppy disk—a format common only a few years ago—or the software to translate WordPerfect 4.0 is practically impossible. On government and industry levels, the problem is magnified: old DECtape and UNIVAC drives, which recorded vast amounts of government data, are long retired, and programs like FORTRAN II are historical curiosities.
>
> The data stored by these machines in now-obsolete formats are virtually inaccessible. The year-2000 problem concerns only obsolete formats for storing dates. It is merely a snapshot of the greater digital crisis that puts future access to important government, business, and cultural data in such jeopardy.

Further consequences of the problem are shown clearly and directly in the powerful film *Into the Future: Preservation of Information in the Electronic Age*, by Terry Sanders.[3]

The film, about the hidden crisis of the digital information, shows some deeply troubling consequences of the problem, such as the badly deteriorated Navajo community archive of video-taped interviews with tribal elders. Intended as a legacy for the younger generations, these authentic and emotional conversa-

tions will soon be gibberish, if the tapes are not converted to some archival material and standard.

Filmmaker Sanders, who was kind enough to join the February meeting to present and take questions on his film, also included interviews with the inventors of the Information Age, including Peter Norton (Norton Utilities) and MacArthur Fellow and Internet creator Tim Berners-Lee. Even handled as it is in a low-key fashion, it is a sobering experience to witness prophets such as these acknowledging the enormity and seriousness of the problem—the lack of agreement, tools, or standards for ensuring the survival of cultural heritage in digital form.

Even with the consequences of this problem seeming so clear and so final, its solutions are not. They will need to accommodate the complexities of technology, the unforeseeability of the future, and the power of the profit motive. In fact, to get closer to solutions, we needed to delimit the subject so that some progress could take place. Needing to jump in somewhere, we determined that a structured, substantive conversation would be in order, among people who live comfortably on the brink of the millennium—both fascinated and troubled by the stage of technology in which we are currently stuck.

Gathering the Group

In order to get at the scope of the problem, we felt that it was necessary to do some "out of the academy" thinking. Our co-conspirator in this project is **Stewart Brand,** who founded the *Whole Earth Catalog,* and wrote *The Media Lab: Inventing the Future at MIT.*[4] Brand brought in most of the Board of Directors of his Long Now Foundation,[5] established in 1996 to foster long-term responsibility. A 10,000-year clock and library for the deep future are its founding projects. The directors are—among other things—all "generalists with a passion for detail."

Douglas G. Carlston is an attorney, and co-founder and CEO of Broderbund Software. As a businessman, Doug brought practical, economic insights to the table. "There's a subtext here which is purely economic. Which is, if you don't have a constituency representing that body of information going forward, you don't necessarily have people with the economic motive or incentive to maintain it continuously." He wrote "Storing Knowledge," as part of the preparatory material for the conference discussion.

The British musician, producer, and artist **Brian Eno** continues to break new ground in fusing the worlds of art and technology in his compositions and performances. He contributed his observa-

tions and philosophies through tales of his creative and technological successes and frustrations. "One of the problems is that when digital material corrupts, it corrupts absolutely. We've been used to analog materials which deteriorate rather gracefully. . . . [A] tape played over and over again does lose high frequencies. But you can still tell what the music is, you can still hear the song. What has happened with some of my earliest digital recordings is that they have become absolutely silent. There's nothing there at all. A lot of people are finding that in all sorts of ways they prefer the type of deterioration that characterizes atoms to the type of deterioration that characterizes bits."

Danny Hillis is Vice President of Research and Development at Walt Disney Imagineering, and a Disney Fellow. He was deeply involved in the invention and development of parallel processing, and was co-founder and chief scientist of Thinking Machines Corporation. Danny brought to the conversation his unique perspective on the big picture. "I have a different view of technology than Alan Kay's, which is, technology is the stuff that doesn't work yet. There was a time when the violin was technology. And in fact, what we're dealing with is that digital technology has proved so useful that we've started using it before it really works."

Kevin Kelly is Executive Editor of *Wired* and the author of *Out of Control: The New Biology of Machines, Social Systems and the Economic World.*[6] Among other things, Kevin contributed several conceptualizations of possible approaches to managing the abundance of information we have. "The Internet is basically the largest Xerox machine in the world. If something can be copied it will be copied. On the Internet, it goes everywhere. But what it doesn't do is it doesn't go forward in time very well. So that's the problem that we have."

Paul Saffo is the Director of the Institute for the Future, a 29-year-old research and forecasting foundation located in Menlo Park, California. Unexpectedly, El Niño made Paul's participation in the conference impossible.

Jaron Lanier is a leading computer scientist and early pioneer in the development of virtual reality technology. He created the interactive video program "Moon Dust," among others. He is also an accomplished musician and composer. Jaron believes strongly that digital information must be kept in perpetual use in order for it to survive. Said simply, "unused data dies."

Howard Besser, Adjunct Associate Professor at UC Berkeley's School of Information Management and Systems, specializes in digital archiving. His multidisciplinary approach led him to identify several points of inquiry: the viewing problem; the scrambling problem; the inter-relation problem; the custodial problem, and the translation problem. These categories provide a useful

structure for examination of the issues. Together with his Berkeley colleague Peter Lyman, he co-authored the conference background paper.

Peter Lyman is the University Librarian, and Professor in the School of Information Management and Systems at UC Berkeley. Peter shared his insights concerning digital preservation with participants as not only a librarian, but as an ethnographer as well. Several of his observations related to social and cultural organization. "So I think the question is: What kind of organizational matrix or cultural orientation can make people want to preserve these things?"

Brewster Kahle is the inventor and founder of Wide Area Information Servers, Inc. [WAIS]—recently acquired by America Online—the Internet Archive, and an on-screen search service called Alexa. Kahle brought with him Alan Rath's sculpture *The World Wide Web, 1997: Two Terabytes in 63 Inches*. The ingenious sculpture captures a moment in the life of the Web and crystallizes in physical form many of the challenges presented by the expanding body of digital information and objects. In his words, "I think the issue that we are grappling with here is now that our cultural artifacts are in digital form, what happens?"

Rath sculpture

The Internet Archive raises the possibility of saving everything. It downloads the entire Internet each day (about 3 terabytes) onto digital tape and saves it. The Archive will provide historians, researchers, scholars, and others access to the vast collection of data on the Web, and ensure the longevity of this information.

Defining the Problem Space

This group was charged with defining the "problem space." In engineering parlance, a problem space is composed of near-term problems that could be solved with tools available today, a middle-term problem set that will take some innovation in today's tools to get through, and long-term troubles whose solutions will require whole new ways of thinking.

The most dramatic images to come out of the two days were the problem-space diagrams introduced by Kevin Kelly and Danny Hillis, and amended by everyone else.

Figure 1 is the simple version: At opposite ends of one axis are bits and artifacts: that is, information in digital form as opposed to actual things. Intersecting that axis are the polar opposites of digital information that is precious (curated?) and all digital information. Add to that a third axis of digital information that is interactive (applications) and digital information that is static (text or

Figure 1

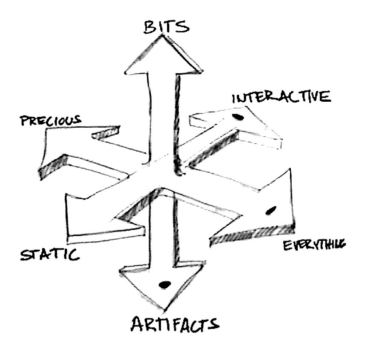

digital still pictures). In this simplified problem space the preservation of artifacts, interactive media, saving everything is very problematic. Obviously this leaves us with static, precious bits as a workable problem. For instance, putting the pages of the 100 most important books on a CD-ROM.

A more expanded version of the problem space (Figure 2) is a multi-axis system composed of human-scale pieces (a text file for instance) vs. huge pieces (all of NASA's data), information that is used a lot vs. information that will be used rarely, a longevity time span of 50 years vs. 10,000 years, static vs. interactive data, and finally digital information where the creator is cooperative in being responsible about using long-term media and the situation where they don't care at all how long it lasts.

In this problem space the long-term problems that will require very different ways of thinking are the situations where information is rarely used, will need to last 10,000 years, are huge in scale, are interactive, and where the creator has been uncooperative. The near-term problem that is more solvable is a data set that is used a lot, is static, is human scale, will only need to last for 50 years, and the creator has been cooperative.

Figure 2

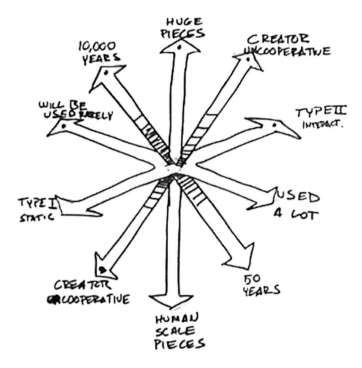

Meeting at the Getty Center

The participants arrived in Los Angeles on Sunday, 8 February, and worked through to Tuesday evening. Together with Stewart Brand, we organized the time on Monday and Tuesday as a series of meetings. All day Monday was a closed session of free-ranging discussion, starting with summary position statements by each participant, and continuing with defining the problem. A summary of the conversations constitutes "Setting the Stage," herein. On Tuesday morning, the meeting participants viewed—again—the Sanders film, revisited the progress made since the end of the previous day, and organized themselves for the afternoon session. On Tuesday afternoon, after a luncheon with a dozen or so members of the press, the group convened for a public discussion of the subject and the progress made in the closed meetings. Present were many journalists; specialists in information management; and library and archives professionals from regional universities, corporations, entertainment companies, foundations, and research laboratories. We also welcomed interested staff, and a few fortunate visitors to the Getty Center. A transcript of the afternoon event comprises "Public Session: Panel Discussion."

The project and the meeting, and the unexpectedly strong response since then, support the idea of the three partners that there is a growing recognition that this interesting, troubling, large-scale problem ahead will affect virtually everyone who uses computers. It is also becoming clear that neither the problems nor the solutions are simply technical. As Michèle Cloonan, Chair of the Department of Library and Information Science at UCLA, noted in her essay "The Preservation of Knowledge":[7]

> . . . the emergence of electronic information will result in a fundamentally different way of approaching [. . .] preservation [. . .] which has been object-based (books, broadsides, maps, etc.) and time-oriented (permanent durable paper should last for at least for at least 250 years). Thus the notion of saving object X for Y years may become obsolete. We will need to secure the longevity of information so that the information itself does not disappear. And it must be done in concert with librarians, publishers, manufacturers and anyone else involved in the handling of information.

The future plan for Time and Bits at the Getty Center is to continue the conversation, make the signal brighter.

Notes

1. Bruce Sterling, *Holy Fire* (New York: Bantam Books, 1997): 31
2. Donald Waters and John Garrett, *Preserving Digital Information, Report of the Task Force on Archiving of Digital Information* [www.clir.org/pubs/abstract/pub63.html].
3. For more information regarding either of Sanders' films on this subject—*Into the Future: On the Preservation of Knowledge in the Electronic Age*; or *Slow Fires: On the Preservation of the Human Record*—please contact the American Film Foundation at (310) 459-2116.
4. Stewart Brand, *The Media Lab: Inventing the Future at MIT,* (New York: Penguin Books, 1988).
5. http://www.longnow.org
6. Kevin Kelly, *Out of Control: The New Biology of Machines, Social Systems and the Economic World* (New York: Addison-Wesley Publishing Co., 1995).
7. "The Preservation of Knowledge," *Library Trends* 41, no. 4 (Spring 1993): 594–605.

Defining the Problem of Our Vanishing Memory : Background, Current Status, Models for Resolution

Peter Lyman and Howard Besser

When we know a book is important, we know what to tell a publisher: print it on acid-free paper. Well, what do we do with digital documents?

PETER LYMAN

Introduction

Digital information saturates most aspects of everyday life: from international financial markets to the grocery checkout counter; from children's mental picture of dinosaurs to Voyager's computer-generated images of the solar system; from databases mapping the locations of toxic dumps to those tracking our retirement funds. What if the digital information with which we manage our lives and institutions were to disappear? What kind of picture of life in the late 20th century could the historians of the future uncover, if the only lasting record of our time were printed on paper?

In fact, our digital cultural heritage is disappearing, almost as fast as it is recorded. Atoms, as in ink on paper, tend to persist. Digital records tend to become inaccessible, rendered unreadable by media deterioration, or obsolete by the pace of innovation in information technology. Consider the following:

Most computers have electronic clocks which will not allow them—or the data, images, and information they contain—to operate past the year 1999. Were this to happen, the 21st century, predicted to be the age of information, would begin with the loss of most of its digital memory, and with it the recent history of science and technology, the information records of government and corporations, popular culture and the digital arts.

Electronic mail and document files, which constitute the informal life of nearly every organization, can disappear when a hard disk crashes.

How, then, can we create a historical record of our digital cultural heritage, like that created by libraries and archives for print, and by museums for artifacts? Are digital signals destined to

11

be a kind of oral culture, living only as long as they are remembered and repeated? What can be done to preserve our digital cultural heritage?

Principal Issues in Digital Preservation

In the development of every new communication medium, there is a moment of realization that the origins of a new era or culture are being lost, and should be saved. This was true of paper, of film and photography, of early radio and television, of sound recording, and now of digital works.

The long-term preservation of information in digital form requires not only technical solutions and new organizational strategies, but also the building of a new culture that values and supports the survival of bits over time. This requires that a diverse community of experts—computer scientists, archivists, social scientists, artists, lawyers, and politicians—collaborate to ensure the preservation of a new kind of cultural heritage, the digital document. We can identify four themes where key issues must be addressed at the start.

- technical profile
- socio-economic factors
- organizational contexts
- legal constraints

Aspects of the Problem

File formats are still being developed without regard for their incompatibility. "Refreshing," or copying files from an old storage medium onto a newer, more commonplace one, is often done as a matter of course. Unfortunately, this addresses only one aspect of the problem: the physical medium. It fails to address the key issue of file formats. A few years ago, many of us had to transfer files from 5-inch to 3-inch diskettes; some files are likely to have been in WordStar or VisiCalc. Such files would be completely unreadable by today's software, which often cannot even decipher files created by older versions of the same programs.

Increasingly, the value of documents lies in their linked relationship to other resources. The Task Force on Archiving Digital Information suggested that physical strata and file format problems might be handled through either emulation strategies or migration strategies, which continually move data into new formats that work with contemporary applications. Such strategies may be

You know in truth, we actually don't know how big the problem is. I feel like this is one of those first environmentalist conferences where there's a lot of people gathered who are thinking there's a big problem.

PETER LYMAN

more effective if coupled with attempts to "exercise" digital documents periodically; using them is one method to make sure that they will continue to be usable. But these strategies become more problematic as we move to information environments that are not fully contained within a limited space. These strategies can work well with models based upon single files or discrete groups of files, but become more difficult to follow when the boundaries of an information environment are unclear or very large. Backing up a Web site or downloading a Web site to a non-networked laptop requires a range of decisions on how much of the Web site is gathered up. What does one choose to move? Only a particular hierarchy of their own files? Or some of the files that are linked to? And if so, how deep does one follow the links? As information environments become larger and more interconnected, can we develop strategies to save these?

Many documents have embedded within them a very useful kind of interactivity. In addition to the problem of saving a given work within its more general context, there is also the problem of saving the various behaviors of a work, and making sure that these persist over time. For instance, a "digital book" might incorporate behaviors that let the user jump from a table of contents to a given chapter, or from a section of text to the accompanying footnote. We need to find ways not only to make the text persist over time and into new display environments, but also to make the appropriate behaviors persist somehow as well.

Short-term solutions cause long-term problems. Another key set of issues revolves around longevity problems that may be provoked by attempts to fix more immediate problems like those involving delivery, storage, and commerce. Much work in recent years has focused on altering file formats in order to solve immediate problems. Compression schemes have been developed to ease storage and delivery problems. Encryption schemes and container architectures have been developed to enhance digital commerce. Many of these file alterations use proprietary schemes and do not adhere to widely accepted standards. These alterations add an extra level of complexity to viewing a file, one that may not work well in future information environments that look radically different from those of today. While some of us may have faith that 50 years from now we'll have the tools to display an ordinary Microsoft Word file from today, the ability to display an encrypted Word file (or one wrapped in a Digibox or a Cryptalope) is likely to be problematic.

Should commercial, proprietary concerns legally override the obligation of copying for the sake of preservation? Copyright

establishes a time-delimited right to distribute the original expressions of an idea, balanced by some public rights such as Fair Use. Copyright laws now also permit copying for the purpose of preservation of printed records, although in practical terms the right to preservation copying is clearest when potential historical interest outweighs economic value. Given the creation of secondary markets for intellectual property in new media, however, there is considerable political pressure to extend the length of copyright, and a growing practice of protecting intellectual property through contract (e.g., licensing instead of selling, and particularly, "shrink wrap" licenses) that do not grant preservation rights, or may reduce the right to use materials that have been preserved.

Broad Strategies for Preservation

A number of different approaches are now emerging to deal with some or all of these problems, and most of these do not exclude the other approaches. Since important experiments and prototypes are emerging from sectors that often do not easily exchange information with each other—hardware manufacturers, software designers and vendors, academic computer scientists, archivists and librarians, and publishers—information is still difficult to obtain.

Save everything. The Internet Archive follows the approach of trying to save most of what is on the public Web in time slices governed by how long it takes their Web crawlers to copy everything they are seeking (currently approximately two full slices per month). Internet Archive, a non-profit organization, uses a data archive developed by Alexa Internet, which generates income from access to "lost" files and data mining. Long-term questions involve how well this will scale as the Internet continues its explosive growth, strategies for making sure these extensive backups will persist over time, by evolving copyright regimes and liabilities, and whether decisions that have been made about what not to save (i.e., the potential liability of archiving, such as pornographic material under legislation like the Communications Decency Act, or protected or inaccessible sites, etc.) may have long-term historical implications.

Employ tested strategies for refreshing documents and data. The practice of moving bits to a new physical storage medium is well understood by those who maintain backup files of large quantities of data. Most large organizations with mainframe computers understand the technical and economic issues involved in periodic

movement of data to new physical strata, and in storage of that strata over time. But this strategy does not take into account the problem that the file formats which are continuously refreshed may not be readable by future applications (the "WordStar problem").

Stay abreast of developing strategies for data migration. We know very little about the process of refreshing, while at the same time moving to new, more accessible file formats. We know even less about what it takes to create emulation software. We need to begin to understand the technical issues and costs involved in following these kind of strategies.

Consider the data "exercising" strategies that meet your needs. The idea that continual community use of a digital object will make it persist over time is a very powerful one, but this is something that we don't yet understand very well. We can imagine that members of the public will continuously convert popular works into forms viewable in newer environments. But we know little about how this will affect any guarantee of the integrity of these works, nor how this strategy will affect less popular works. We need further work on the likely impacts of these strategies.

Think ahead, and assume responsibility for the long term. Innovators within the archives and records management community have begun stressing "life-cycle management," wherein information professionals become involved with documents as early as possible in the document's life in order to best ensure that that document will persist over time. This paradigm (which differs from the late-stage interventionist model that has characterized much previous preservation work) has been applied particularly to collections of electronic records.

Specific Suggestions for Use in the Short Term

Until a viable holistic approach emerges, what should we do to ensure that our works will persist as long as possible into the future? In the long run, both print and digital preservation strategies are best sustained by the definition of technical standards, but standards evolve from "best practices," which are currently evolving in the following areas.

Save in the most common file formats. The more files that exist in a given format, the more likely that file converters or emulators will be written for that format (because of economies of scale). Conversely, files stored in less common formats will face more obstacles being viewed in future environments.

Avoid compression wherever possible. Future viewing environments will not necessarily know how to decompress current compression formats. When compression is necessary, use the most common compression formats.

For image capture, use standard color bars and scales. Color bars and scales within an image can be effective in rebalancing color and in classifying image size for future viewing environments.

Keep a log of processes and changes to the digital object. Many seemingly innocuous things we do to a digital object may have significance for future viewing environments. Keeping a record of processes and changes done to an object, and the tools used, should ease adjustments to future environments.

Save as much metadata as possible. When we create or alter a digital object, we usually have much greater access to information about that object than at any other point in its life cycle. Because we know so little about future viewing environments, we don't know which of the seemingly innocuous bits of metadata may later prove important to those environments. Embedded metadata will allow future users and applications to know what type of digital object this is, what file format, what will be needed to emulate a viewer for this file, etc. The more information we can save, the more likely we will be able to provide future generations with a "key" for unlocking the contents of whole classes of data. This is the Rosetta Stone strategy.

Exploring Existing Models of Effective Preservation

The wealth of practical expertise developed in the preservation and conservation of the traditional media for our cultural heritage has much to offer to the challenges relating to digital heritage. Although bits and atoms have very different technical profiles and social contexts, the progress made in the management of the acidic paper crisis and in conservation of works of art is the best guide available with which to explore strategies for preserving digital documents. This case has resulted in some lessons that might be usefully applied to the current situation.

The Case of Acid Paper

The rapid expansion of the use of paper records in the 19th century, and the need for inexpensive materials for mass production techniques, led to the widespread use of wood-based, acidic

paper which quickly oxidized and turned brittle. This economical and technical decision had unanticipated and alarming long-term consequences for the persistence of the written record. A number of preservation strategies which were required to address the problems caused by these decisions might serve as instructive models for managing digital documents.

- The commercial firms had to redesign their technology for paper production.
- Articulating the tradeoff between costs and durability of the paper medium raised the consciousness of publishers to make better decisions about the long-term cost and value of information through its entire life cycle.
- Librarians now monitor and manage storage conditions (especially humidity and heat) that speed the rate of decay of paper. They regulate the use of brittle books, and are trained to intervene with repairs and conservation.
- Materials and conservation science have developed new techniques for large-scale de-acidification to preserve important and vulnerable documents.
- The information content of vulnerable paper documents is often saved by their conversion to microfilm or digital media.

In sum, the strength of the strategies that have been developed to preserve paper documents is that paper is relatively well integrated into organizational frameworks of various kinds, and managed by professional librarians and archivists who are aware of the problem and trained to manage it; and, given the persistence of the medium, the fundamental strategy is educational—documenting the conditions and practices that reinforce the essential stability of the medium.

The weakness of the preservation strategy for paper is that awareness of the problem often becomes apparent at the end of the information life cycle, when there is relatively little economic incentive or organized social interest to solve it. "Preservation," then, is not a systemic solution, and for this reason it is unlikely to attract new technology. While all of the strategies for preservation of paper are useful models for enhancing the persistence of digital documents, given the pace of technical innovation it is still possible to redesign the medium itself to enable the persistence of bits over time, if the technology community becomes aware that its work constitutes a cultural heritage which is disappearing. As printed documents lose their market value, the methodology for preserving them may shift to "access," that is, minimizing the potential costs involved in finding and using a document. The access rationale often leads to the digitizing of digital documents,

both to preserve the original from the wear and tear of use, and to make it possible to use a document without travel.

To test this link between preservation and access, the non-profit initiative Journal Storage Project (JSTOR) was created by the Mellon Foundation as a national digital archive of back issues of scholarly journals (see http://www.jstor.org). Instead of focusing on the technical issues, JSTOR's approach is through the economic model. Its mission is to explore the possibility that individual institutions would agree to fund a national digital archive dedicated to preservation and access of rarely used but potentially important journals, in place of local copies of the same journals which require ongoing space and maintenance costs.

The Important Differences Between Atoms and Bits in Preservation

However instructive the lessons of paper preservation may be, bits and atoms are very different information media, which will require very different preservation strategies. Without intervention, the default condition of paper is persistence; the default condition of electronic signals is interruption. The characteristic persistence of digital documents is suggested by the term "memory," a term which simultaneously manages to suggest both the persistence of memory and the possibility of forgetting. Recognizing the principal differences between paper-based and digital documents is a critical element in their long-term protection.

As signals, the persistence of a digital document is dependent upon the nature of the artifacts that it may inhabit at any given point in time. In active memory (RAM), it is dependent upon the presence of electricity. Stored on a ferro-magnetic medium (disk or tape) or optical medium (CD or other), it may well outlast the operating system which is required to access it, but in any case neither medium is rated to last as long as 50 years even in ideal conditions. While new physical media (such as glass substrate optical disks) may be engineered to last longer, a more critical problem is that the file formats in which digital documents are encoded will not be readable by future systems unless proactive measures are taken to make them persist. Suggestions to address this include periodic migration from system to system as quickly as the process of innovation demands, or periodic creation of emulation software to make these documents accessible on future systems.

Both the form and content of knowledge in digital forms are still being continuously reinvented through a process of technical innovation; thus digital documents present a continuous problem

of obsolescence, not only in their form but in their content as well. This obsolescence is both technical and economic, in that there must be continuous and active technical investment to preserve digital documents.

Organizations dependent upon digital records, such as corporations and governments, need straightforward risk management strategies for "refreshing" digital documents, focused upon minimizing the vulnerability of the media upon which they are stored, and upon moving data from one system to another. (Corporate data processing centers, university computing centers, and other mainframe-based organizations understand issues of backup and refreshment of data, but don't necessarily understand the implications of real migration, particularly for more complex digital documents, or digital information within software environments that are still evolving rapidly and thus creating subtle kinds of obsolescence.)

Unlike print, which has had 500 years to create institutional contexts, digital documents are still in the early stages of innovation. Typically, in the first phase of innovation a new technology will imitate an older one; thus digitized documents are created from printed originals as a means to create new value by expanded access. But new social and organizational contexts made possible by digital documents are still emerging, only suggested by terms like "virtual community" and "distance education." In this sense, the organizational contexts which are responsible for digital documents remain to be defined and founded.

Who is Responsible?

There are serious questions as to who will take responsibility for making digital information persist over time. In the world of printed publications, owners of intellectual property rights generally do not take on this role, but cede it to libraries. In the digital world, legal, technical, and economic factors may preclude libraries from doing this. Even if the legal and technical issues are overcome for libraries (or if content owners decide to manage persistence over time themselves), we may need to develop social and legal mechanisms for "rescuing" digital information when the organization in charge of making it persist no longer has the resources or will to do so. We also need to deal with the issue of how many copies of anything digital we need to save; published material persists in part because of redundant saving of the items.

In the debates about the forms that intellectual property might take in dealing with digital documents, such as the

Commerce Department's Report of the Working Group on Intellectual Property Rights (September 1995) and subsequent proposed legislation, there is tension between two principles. On the one hand, it is often granted that preservation is a legitimate public good which should have special status in the law; on the other, the concept of public good is being replaced by the commodification of digital knowledge in order to create the electronic marketplace.

In the print world, the space between is occupied by the doctrine of Fair Use, which exempts educational and preservationist activities from copyright. In the digital world, there is as yet no Fair Use; indeed the White Paper rejects the concept as an unfair subsidy of education by publishers. Thus, for example, the paper on digital preservation commissioned by The Research Libraries Group and the Commission on Preservation and Access suggests that "certified archives" may have to be more like time capsules than archives or libraries: that is, removed from public access until their contents had come into the public domain with the end of copyright, whenever that might be.

The obvious question is, Given this withdrawal from use, what incentive would exist to fund such an archive? Further, it is increasingly likely that digital documents will not be governed by an intellectual property regime at all, but will be protected either by technological means ("Cryptalopes," digital boxes) which would make them even more difficult to preserve, or by licensing mechanisms under the Uniform Commercial Code section IIB (e.g., "shrinkwrap" licenses). One dimension of the creation of methodologies for the preservation of digital documents, then, must be participation in the ongoing legislation, litigation, and treaty negotiations which are shaping the intellectual property regime within which digital documents will be managed and preserved.

As in every other dimension of the information revolution, our thinking about the persistence of digital memories tends to be trapped inside the cultural habits of an industrial age. Thus we speak of the 21st century using metaphors of the 19th century: information "highways," "digital libraries," "electronic publishing." The problem of preservation or persistence of digital documents, "time and bits," might best be solved by changing the rules and adopting new visions and metaphors that would both reflect and redefine the way we think about information.

Storing Knowledge

Doug Carlston

Summary

Content, data, information: all are different terms for knowledge. Humans store knowledge because we benefit as a species from the ability to communicate information over time and space with accuracy. As our dependence on communicated knowledge has grown, certain problems—such as developing uniform standards for conveying knowledge, maintaining the integrity of information, and retrieving specific knowledge from a storage or transmission system—have become more intransigent.

Digital devices have offered the promise of greatly facilitating both the maintenance of informational integrity and the capacity for information retrieval. However, digital storage is new. As a result, bit interpretation standards are not yet fully evolved. Most media sacrifice physical longevity for capacity. And in the area of process knowledge, such as computer programs and algorithms, interpretive hardware devices are also largely unstandardized. In short, we have three problems to solve:

- the longevity of the medium on which information is to be stored,
- the longevity of the hardware systems that permit us to perceive the information on the medium, and
- the longevity of the systems that let us interpret the information that we perceive.

There is actually a fourth problem that may prove even bigger than these, and that is simply one of data management. We are creating so much archival content that the task of sorting, collating, renewing, and preserving the data is proving increasingly problematic, as long as human intervention is required for these activities. It is also expensive, and any solution to the problem must take into account the questions of who pays and who benefits.

Why Do We Preserve Knowledge?

A part of the human competitive advantage lies in our ability to communicate. That skill permits us to act cooperatively, with far greater effectiveness than any individual could achieve acting

alone. We seek to pass on our knowledge, too, by teaching our young, so they can benefit from our knowledge and experience. As our notions of community expand, it becomes increasingly necessary to find ways to communicate over ever-increasing gaps of distance and time.

Writing and drawing permitted information to be forwarded over great distances through chains of people with less degradation in accuracy. In fact, most information that has been preserved over long periods of time and space survives because the knowledge is recorded in some fashion, copied, and broadly disseminated. Copying introduces its own problems, of course. Degradation or "improvement" of the original content is common, and the original meaning may frequently be changed or lost altogether.

One could argue that, although there might be some benefit to the individual in passing information over expanses of space, passing information far into the future conveys no possible benefit to him and is, therefore, unlikely behavior. It sounds too altruistic. However, William Hamilton's work on a genetic basis for altruism illustrates that altruistic behavior makes sense to the extent that it supports descendants and community and thus increases the survivability of one's DNA (Hamilton, 1996). Knowledge sharing is thus genetically selected for. It is cooperative behavior that "rewards" one's DNA, at least to the extent that it is shared within one's kin group. As we talk about individuals and groups that "benefit" from activities in this paper, we will include this kind of genetically motivated altruism in the notion of benefit.

This argues that the value of information sharing is greatest over the shortest extents of space and time. However, we have seen repeated instances where human cultures have suffered severely from a failure to acquire or preserve knowledge at a farther reach. Chinese emperors who burned their navies to prevent the inflow of external ideas saw their societies suffer in the long run as a result. The loss by various human societies of their hard-acquired special knowledge, from Damascus steel to Mayan astronomy, arguably factored in their failure to recoup their previous vibrancy and strength.

It is important to consider whether we are more concerned with forms of information preservation that depend upon continuous human involvement in the preservation process, or with forms that explicitly anticipate a cultural discontinuity that makes such dependency unlikely, for the solutions are likely to be quite dissimilar. It is equally important to consider the economics of preservation, for economic considerations frequently make explicit patterns of effort and benefit that are all too frequently

buried in popular rhetoric. A process that depends upon continuous human effort must also entail continuous perceived benefit.

The Problems with Preserving Knowledge

The ability to communicate over large expanses of space and time gradually altered the human condition. Governance of great empires became possible. Task specialization became increasingly possible, as people became able to depend upon the knowledge-building capacities of others. We came, in time, to depend upon external knowledge, and this created, in turn, a set of needs tied directly to that dependence.

Recording systems, such as alphabets and numerical conventions, emerged and began to compete. These systems made possible currencies and non-barter trade, codification of laws and rules, literature and the arts—in short, most of the elements of complex society. Empires depended upon their ability to administer huge territories, to react swiftly to threats, and to encourage commerce. Record keeping became integral to their economic and political systems.

Just as the printing press made possible widespread literacy, new technologies have made it increasingly possible to create and store data. This process continues at an exponential rate of expansion. It is estimated that we have created and stored since 1945 100 times as much information as we did in all of human history up until that time! Of course, in order for that data to have any value, it must be possible to search and sift through it with relative ease, to show it to intended parties and secure it from unintended ones, and to save it for as long as it is useful without degradation in either its legibility or its comprehensibility. These have always been the concerns with information; the problems, however, demand new solutions as the scale of the operation magnifies beyond what was previously conceived.

What was previously done by hand must be automated. Searching for data, rerecording data to preserve or transfer it, encrypting information to protect it—all these processes have come to depend upon automation because of the volume of information traffic. But in order to automate these processes, information must be in a form that machines can handle. In the Fifties and Sixties researchers experimented with both analog and digital forms of information processors. For reasons that lie beyond the scope of this paper, the digital devices largely won out, and today most data must be encoded in digital form to be enacted upon by information processing devices.

Why We Digitize Anyway

Machines can copy and transmit images and sounds in many different ways. Cameras are over 150 years old. Voice recordings date from the turn of the century, as do telephonic and radio transmissions. None of these innovations depended upon prior conversion of content into a digital form. However, all suffer from similar limitations. Repeated copying of the transmission quickly renders the content incomprehensible. The content is largely unsearchable. (Would that, even today, we could search voicemail for that message we really want to listen to!) And, in general, the information is hard to compress without losing quality, so it tends to take up a great deal of space (at least relative to storage of the same information in digital format on the same medium).

Enter the IBM punch card. Suddenly we have a format we can search. Copies are exact and never degrade (although the paper medium of the card certainly does!). The key to it all is that the information has to be encoded in a form that a machine can deal with—a digital format. However, that encoding introduces some new problems even as it makes some of our original concerns more tractable.

Digital content is easier to store, search, encrypt, and compress than its analog equivalent, at least if you have a computer. It is harder for a human to interpret, for it introduces at least several additional steps in the interpretation process. Now it is not sufficient to: (1) recognize the alphabet used to convey information and (2) speak the language encoded in those alphabetical characters. Now one must also: (3) be able to discern or possess a device that is able to discern the ones and zeroes on the storage medium, and (4) know or possess a device that "knows" the encoding algorithm that translates the series of ones and zeroes on the medium into a taxonomy that one can interpret. In other words, one is now dependent upon a machine to perceive and interpret the digitally stored information.

Now, in addition to previous concerns, one has to worry about whether that device will remain in proper working order into the future or whether similarly purposed devices in the future will be able to read and interpret the same data upon the same media as the current device does. In short, we now have three important and interconnected classes of concerns connected to the long-term storage and retrieval of information: (1) the longevity of the medium on which information is to be stored; (2) the longevity of the systems that permit us to perceive the information on the medium; and (3) the longevity of the systems that permit us to interpret the information that we perceive.

Where Are the Real Problems?

The Longevity of Media

Let's look at each of these groups of problems separately first. The first group centers on the media upon which or within which we store information; at first glance it would appear that this is an area in which we are doing a far worse job at preserving our intellectual heritage than did our forebears.

As we move from clay tablets to papyrus to paper to cellulose to magnetic tape to optical plastic, we move to increasingly ephemeral and fragile forms of storage. Many films and most magnetic tapes that are more than about 25 years old are too degraded to be viewed or heard. Most computer code that is 10 years old is on unreadably degraded media (and, moreover, usually recorded in a manner unintelligible to currently available computer devices). Libraries whose old paper card catalogs served them for 100 years find that microfiche catalogs wear out in a fraction of that time. We seem in many ways to be moving backwards, toward increasingly temporary and fragile systems of information preservation.

On the other hand, modern technology has made it increasingly easy and inexpensive to copy information. Instead of a monk devoting his life to the careful recopying of a valued manuscript, a Xerox machine permits one to achieve the same result with a fraction of the time or effort. As a result, the natural culling process by which a product was carefully evaluated before being deemed worthy of copying (thus forcing it to be subject to occasional analysis of its perceived value) is partly eliminated. Instead, the information is increasingly as likely to become lost in a blizzard of content as it is to become lost from the deterioration of the media itself.

Add to this innovation, therefore, the innovation of digitization, which permits vastly improved searching. Link that with a global information network that permits individuals worldwide to search for, retrieve, and copy information that they deem to be of value. Then, the ephemeral quality of the media seems of less concern, at least as long as the information is likely to be of continuous benefit to some group of people in this network, as long as that group is permitted to maintain the content, and as long as some society to which some of these people belong is able to maintain technical continuity. After all, earlier forms of storage, such as analog tape and paper, do continue to exist—it's simply a matter of cost and time to archive information both ways.

The three conditions above are not insignificant, however. It is not at all uncommon for that which was believed worthless to

be greatly valued at a point in the future. With respect to the second condition, history is replete with instances of intentional destruction of information which is deemed inconsistent with or inimical to a particular religious, cultural, or ideological viewpoint. The heterogeneity of a global networked society may be helpful in some respects, but that same global society may fail to protect the knowledge of groups whose cultural or linguistic traditions are not part of the emerging global standards. Nor is it at all certain that such groups would belong to, or be able to draw on the skills of, whatever source of technical continuity is needed to preserve their information. In other words, these three conditions make it almost inevitable that valued information will be lost. Creating and storing content on a more permanent storage medium such as paper may be a necessary condition for the long-term survival of most content, although it is certainly not a sufficient condition by itself.

The Longevity of Perception Systems

As long as humans were able to use their built-in perception systems to observe stored information, no issue of an appropriate standard was ever raised—our standards were hard-wired into our physical selves. But the moment Thomas Alva Edison created his cylindrical audio recording, we began to become dependent upon mechanical devices to transmute information into auditory or visual signals that we were capable of hearing or seeing (whether we could understand those perceptible signals or not).

This created a real problem for future receipt of all kinds of stored content, not just digital content. Finding devices to play 33⅓-rpm vinyl records is becoming increasingly difficult. Old film formats are equally hard to view. Just as 5¼-inch floppy disks are now archaisms of digital content, many analog storage media suffer from incompatibility with modern electronic devices.

In most cases, it is possible, as long as the original media are still functional, to have the content copied from the archaic media format onto new media formatted for a modern device. This is often an expensive proposition, however, and is usually performed by specialized agencies that maintain legacy systems and that have built highly original conversion facilities. That these kinds of operations are still largely small, specialized businesses suggests that many people feel that the historical content in their possession is not worth the cost of keeping currently readable. It might be worthwhile investigating the cost of developing hardware devices capable of reading (if not interpreting) the broadest range of media, if only to permit more widespread conversion of data in archaic formats.

The further constraints discussed at the end of the previous section apply equally here, with the additional caveat that a

perception device will not be appreciated in the abstract, but only for the kinds and quantity of data, the perception of which it makes possible. In brief, no data means no value, and, shortly therefore, no such device. Of course, generalized analytical tools should always be capable of detecting most forms of inscription, so there will always remain the possibility of re-inventing the appropriate device, should the need for it become evident only in the future. The issue is one of cost—the absence of a readily available device requires the re-invention and construction of a one-off, which creates a higher threshold of needed value in the data to justify the expense.

The Longevity of Interpretation Systems

Even where the storage media have endured and the information has been recorded in a perceptible manner, all too often the meaning of the data escapes us. Whether we are talking about Inca knot records, ancient cuneiform writings, or computer programs written in 1401 Autocoder, all too often we fail to possess the keys to unlock a real understanding of the meaning of stored data.

However, the picture is not uniformly bleak. Many interpretation systems are quite new and are an integral part of the explosion of stored data which we are experiencing. It will take time to discover which will become standards, widely comprehensible over the eons. Yet, in at least one area, great progress has been made.

In the case of human language, the picture is bright. We are well on our way toward a global standard—English. It is not only now spoken by a higher percentage of the globe's population than has ever spoken a single language before, it has also the virtue of being highly stable, for it has remained consistently comprehensible for 500 years (which is unusual among languages). Change in language slows as means of fixing it increase (i.e., books, films, recordings), and the dominance of English in global film and song is probably as important a factor in its standardization as breadth of its use and the depth of the literature.

But the problem takes on a whole new dimension when we talk about process information—content that consists of a series of steps or instructions for a particular device to enact. Computer programs for obsolete computers may or may not be written in archaic computer languages. In either event, reproducing what the obsolete machine would have done when fed the content is a challenge of sometimes daunting proportions.

Yet with increasing frequency our content consists of, or contains, process information. If one viewed this paper as a word processor file, not in its ones and zeroes form, but already transliterated into its English alphanumeric form (but before a computer had processed the file), one would see, before the reasonably

comprehensible words which you are now reading, a great deal of apparent gibberish. That gibberish consists of a series of instructions to the word processing program telling it which type fonts and sizes are being used, what margin settings to use, kerning settings, paragraph standards, and so forth. If this word processor program were lost or modified (as it has been almost every year), it would not be easily possible to deduce the exact form and layout of this paper, even if most of the thoughts could still be fairly readily perceived. This is a trivial example, since the layout of this paper is not of great importance, but the point should be clear—process information is everywhere and, with increasing frequency, it will not be possible to perceive the full expression of the content-creator's intent if the ability to perceive the process information is lost.

Imagine, if you will, that we are talking about process content that represents the instructions for building a virtual space and populating it with still and animated images tied to sounds. Even if one could disambiguate the various data forms and figure out what was image, what was sound, and what was descriptive code, the author's expression is virtually impossible to deduce absent its interpretation via his original processing device. If in the future it becomes common to create digital wire models of complex inventions and other devices in lieu of written words, we will have an entire body of obviously important process data held hostage to its original interpretation device.

Perhaps in these areas we just have to give it time. We do seem to have some movement toward standards—numerical bits have been translated in a reasonably consistent way into numerals and letters of the Roman alphabet (and others), a necessary first step toward a process Rosetta Stone. And there appears to be a compelling universal interest in standardizing the operating systems and chief applications of commonly available computers, although these standards themselves continue to evolve at a hazardous rate. Perhaps this process will not continue indefinitely, in which case we are confronting merely an interim problem while the universal standards are finally worked out.

The Management Issue

One of the reasons that valued information is increasingly converted to digital form is simply so that it can be treated mechanically rather than manually. As we mentioned earlier, digital data is far easier to search, compress, encrypt, copy, and disseminate by automated means. Without automated data processors, the explosion of data in the last 50 years would have created an insupportable burden on the human population. We would

necessarily have had to decide to abandon some simply because the cost of management of the content was beyond our administrative capacity.

However, automation does not really solve the administration problem. It just moves the yardsticks, permitting a single person to handle a larger territory (and, incidentally, changing popular expectations about what kinds of information can and should be preserved). Even if all information were intended by its creators and by authorities to be publicly and freely available (which is patently not the case), the challenge to create an environment to permit an at-will link between any record and any individual is a non-trivial task. That may, indeed be the ultimate result of the Internet revolution, and as search engines and intelligent agents are rapidly refined, the realization of this vision becomes plausible. After all, we are talking about a process in its infancy.

But most information is not available for free, at least at inception. It is often kept in confidence until that point in time when its owner perceives that it has no further proprietary value. What happens to it then is the subject of the next section, but let's focus for the time being simply on the question of the management of proprietary knowledge.

Understand that our beginning hypothesis was that humans preserved information in order to gain a personal benefit. There are forms of personal benefit that would describe behaviors in which one gave away proprietary knowledge (either to be seen as generous or out of a personal perception that the general public benefit would also be beneficial to oneself and one's descendants). Assuming, however, that there are many instances in which individuals do not see benefit in giving away the information they possess (banned books, personal tax records, next quarter's earnings, secret police files, what really happened in Nanking, etc.), the question of how to preserve information even for the limited purposes of the current possessor creates administrative headaches that have already created calamities of the first order.

Critical IRS and Social Security records have been lost or destroyed, valued books lost within libraries due to misshelving, commercially valuable film archives damaged beyond repair by the simple passage of time. Even if valued content is stored in non-digital, longer-term formats, indices into that content must be kept in digital form to aid retrieval and multi-level searches. These indices must not only be constantly renewed; they must also be "exercised" (i.e., used and the results compared with the request to ensure continued integrity of both content and index). In the long run, however, much data will either be "put out to pasture," without review or renewal, or else it will be editorially sorted, with the valued preserved and the unvalued discarded.

The Cost of Data

The real problem of long-term information storage, whether intermediated or not, however, is one of cost. The future cannot make payments to the past (if it could, I have no doubt that some scoundrel would abscond with the net present value of all future sources of revenue), so the value of content to individuals in the future is irrelevant—what matters is the value people currently impart to the preservation of information for the future.

This is not a hopeless proposition. Proprietary information, as we noted above, will be preserved for as long as the proprietor considers that it has value to him. After that, if it is in his exclusive possession, he will put it into the public domain if he does not consider that it does him harm, and if he is either required to do so or if he believes that it will be publicly valued and that he will garner some benefit from that value. If it is not in his exclusive possession, upon the expiration of his ownership, it will automatically become part of the public domain.

Cultures that pride themselves upon their accumulation of knowledge from the past should be equally assiduous about preserving new knowledge for the future. It is part of the culture's statement of worth, a kind of conspicuous consumption of financial resources intended to display to all the cultural value of the society vis-à-vis the rest of the world. (The pyramids, which seem similar in intent on the surface, differ in that they were primarily a statement to the world of the dead.) Further, to the extent that a society has grown and prospered due to its reliance on and use of knowledge and the information sciences, knowledge and its preservation might be generically protected out of a general sense that information is good stuff and just might come in useful in some unknown way in the future.

The question is for how long. Hamilton's work would suggest that the value of altruistic acts declines with each succeeding generation, so we should be far more interested in short-term than long term information use and preservation. Short of the survivalist's instinct to bury away important information for the rainy day of Armageddon, it will be easiest to find resources to pay for the indefinite preservation of content that represents what people currently believe to be defining works of human greatness. What about the rest, however? What about the Van Goghs or Franz Kafkas, whose genius was unrecognized in their own time? And what about more mundane information, such as genome records for existing species, rainfall records, or popular music?

This is where the economics of storage get important. One solution would be to "tag" content with the financial resources to preserve and maintain it indefinitely into the future. In other words, find a vehicle for individuals to donate money to preserve

particular content, and develop a methodology that uses the best of non-digital backup techniques along with digital preservation and indexing, and a program for refreshing and "testing" the content on a regular basis into the future. This is not the lowest-cost road, and we may have, in the end, to make value judgments about the level of protection we can afford to afford much content. Multiple tracks with separate pricing structures might permit preservation donors to make choices that fit their pocketbooks.

Regardless of the exact approach that is eventually chosen, we should not lose sight of the fact that maintaining continuity of content is the ultimate goal, not just maintaining digital continuity, and best practices in most cases will involve preservation on a variety of formats, including hard copy or analog magnetic storage, as well as digital.

Setting the Stage :
Summary of Initial Discussions

Margaret MacLean

Monday, 9 February, 1998 : The Closed Sessions

Stewart Brand guided the conversation through its early stages on Monday, starting with a summary view of the thinking of each of the members of the group. Each was asked to describe his view of the problem, highlighting what he found particularly important, or where he might contribute. Questions to be kept in mind were: What is the true nature of the problem? What are promising solution paths? What would be helpful to get *right* at the start?

Kevin Kelly began with his version of the nature of the problem, employing a method of envisioning possible futures developed by the Global Business Network, of which he is a member. He sketched out a quadric showing four different scenarios of how the situation might be seen. The X-axis represents the degree of the problem. The Y-axis represents the degree of intervention its solution could involve. In the small problem/small intervention scenario—"in praise of forgetting"—we might hear "Okay, we lose some things, so what? It's not that big a problem, so we don't have to do very much."

The lower right corner is where it is recognized as a serious problem, but no intervention is likely. In that scenario, "The short now," the view is that it's a serious problem, and we might well lose a lot of stuff, but we don't think we can or should do anything about it.

In the huge problem/huge intervention scenario, we would do whatever we could to go back and, say, resurrect all the unreadable NASA tapes. A brief exploration of the scenarios encouraged the group to visualize the possible perspectives that might shape solutions.

For the purposes of this discussion, Kelly's definition of data was anything that can be copied. [Brand offered that this might now include sheep . . .] Knowledge, he continued, cannot be copied, but it can be transmitted. He added cautionary suggestions: that un-exercised data is worth more than no data at all; that one should keep to a minimum the amount of exercising as well as the amount of data exercised.

Although the subject came up several times, the group agreed that it would be preposterous to propose any kind of

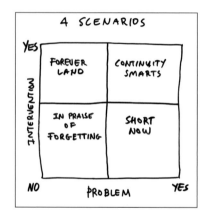

selection criteria on what information should be saved. Many good reasons were cited, including the view that no one has enough wisdom to know which data might be valuable from another perspective in the future, particularly when you consider the analysis of large amounts of seemingly useless data which might have important information en masse.

Danny Hillis was inspired by a small replica of the Rosetta Stone, finding three interesting lessons in it. One was the impossibility of predicting future importance, as was noted above. Reminded of the random serendipity of its discovery, he found the second lesson, that the reason we have this remarkable "decoder" is because it was lost. Had it been set on a pedestal all those centuries, it would likely have succumbed to some vindictive, political whim. In fact, we have it now, and all the information it bears, because it, like the Dead Sea Scrolls, was lost for a long time. This lesson put the "preservation by vault" idea into circulation. The third lesson was particularly appropriate: when it was found, it was immediately recognized as something important. This is a property that our current electronic media do not have. Not only did it require no intermediary device for reading, it offered its own thesaurus.

This line of reasoning brought Danny and the group to focus on possible ways out of the "digital gap," or "second dark age" in which we find ourselves. One was a kind of improved and robust stone tablet, which could store important information indefinitely and could be read without dependence on devices other than human eyes. He favored devising a mechanism for people who care about preserving, made available in a distributed and nonproprietary way.

Describing himself as a businessman, Doug Carlston chose to view the problem through the filter of economics, asking "Why do people want to store information in the first place?" His first four reasons were self-evident: short-term economic benefit; investment, with the assumption that its value would increase over time; for its recognized practical value—proprietary or disseminated; and to save images that provide comprehensive views into history.

His fifth reason—to maintain diversity—is rather more esoteric, and important. Conjuring the image of the burning Sarajevo library, he noted that information is protected as a bulwark against the human propensity to eliminate all traces of a particular point of view or a particular culture. From a gentler perspective, one can see protecting information about populations that die out, leaving none of their own descendants to represent them. The economic subtext here is that there is no constituency representing that body of information, and there is also a lack of economic motive

or incentive to maintain it conscientiously. If continuous management is not possible, can media perception and interpretation systems persist for a long period of time without human intervention? It is doubtful, even with sufficient funds and wisdom. A single mistake, a broken link, and the chain of stewardship is irreparably severed.

Keeping to the theme of imagining particular "solution paths," Brewster Kahle proposed the idea of breaking the preservation process into two parts: into access-oriented media—easier to read and write—and long-term, say 10,000 years, like a time capsule that's really hard to write.

Peter Lyman, an ethnographer/librarian, pursued the idea of culture as a means of remembering. Noting the examples of the ancient stories of the *Odyssey* and *Iliad* transmitted orally through many generations, then in written form by Homer; and similar oral traditions in Bali, he spoke of preservation independent of any technology at all. He recounted his encounter with a librarian in a Balinese university who answered Peter's request for a recitation of a story by standing up and singing at the top of his voice, spontaneously joined by everybody else in the library.

In the case of print, of course, Peter noted that the need for a more institutional strategy gave rise to libraries, which took on the primary responsibility for preserving paper documents and for giving people access to reading them. His question now became—What kind of organizational strategies are going to form around digital communication?

In turn, Jaron Lanier demonstrated that making multiple copies of things is not a sure-fire hedge against loss. His "natural history of software" goes quite far beyond platform drift. Even in this drift, certain qualities of platforms become locked in and standardized. A favorite example he cited was that when undergraduates come into computer science departments, they are told about the idea of a "file" as if it were a fact of nature, as if it were as fundamental and immutable as a proton. He likes to point out that the idea of a file has become locked in place as an idea because of its use in systems. In fact, it is a human invention that resulted from decisions that might easily have gone another way. The first version of the Macintosh didn't even have files.

Ben Davis recalled a project of his to make an interactive videodisc on the Chin terra cotta army in Xi'An, China in 1986. A huge amount of money was spent on a trip there to collect archival material and images, with the intention of putting it on videodisc, and programming it with HyperCard, to produce this wonderful interactive thing. By 1990, though, given the fate of the videodisc, the only way to get it out was on CD through the Voyager Company. They had to cut the amount of material

collected down to a few QuickTime movies and a few stills. Voyager has now gone out of business. The whole collection of data ended up in a sad sort of limbo. Ben's example showed that at every point in information's existence, there has to be a level of economic support for that information consistent with the cost of preserving information. And if at any point that economic support isn't there, the information will not be preserved.

In what Ben presented, a number of people found particularly interesting that the first version on the videodisc was an attempt at an elaborate view into a body of information. The next version was a simpler view into a much-reduced subset of that information, with a very different interface. It became nearly inaccessible almost immediately. The situation had not been allowed to progress to the point of saving a representation of how people looked at the first version. That would be impossible. Davis concluded that the problem of saving the data along with its designed interactivity was unsolvable unless, as Lyman had noted earlier, one can reinstate the whole culture of interacting with it.

As a musician, Brian Eno has faced most of the recording and storage challenges [and disasters] known to this group, and then some. He told an alarming and illuminating story that happened to him. "Ampex brought out a new kind of recording tape, multi-track recording tape which everyone used. It was a very good—sounding tape. And it turned out about 12 years later, when you started to play back those tapes, that the oxide fell off as they were playing; you could see heaps of oxide which was your music falling off the side of the machine. So what everybody had to do was to bake the tapes for three days at about 56 degrees centigrade. And then they could be played back just once and transferred as you played them back. You got one chance to get it right. And everybody had to do this with their multi-tracks. You still have to do it. If I want to re-mix something from that time, I'm going to have to go and bake it. This was a very recent story of a disaster of that kind. It was 4 or 5 years—there was a lot of stuff."

Having completed this initial survey to establish the terrain to be explored, the group continued untangling their ideas—banishing some and sifting in others –well into the evening. On Tuesday morning, Stewart led the group through a process to distill the progress made over the previous 24 hours. They then turned their attention to mapping out the afternoon public and press event to ensure the clearest and most interesting presentation of the problem, its analysis, and some of the guidelines they had developed for thinking about solutions.

Public Session : Panel Discussion

The final panel discussion held in the Harold M. Williams Auditorium at the Getty Center was audio/videotaped. All of the participants except Jaron Lanier were present to give summations of their insights and to answer questions from an audience of some 250 journalists, archivists, technical specialists, Getty staff, invited guests, and visitors to the Center. What follows is an edited transcript of the entire panel session. In some cases, audience members did not identify themselves during the question and answer period.

MacLean

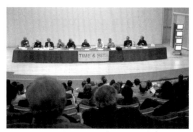

Public Panel

► **MARGARET MacLEAN:**

Good afternoon. Welcome and thank you all for coming.

The Getty Conservation Institute and the Getty Information Institute and The Long Now Foundation have collaborated over the last year or so to bring together—as part of a larger project—a number of extraordinary people to think about the problem of protecting digitally recorded data over the long term.

This is a problem that has many levels and many implications, and Stewart will be talking about that shortly. I have a couple of comments, though, that might help to contextualize the panel session this afternoon.

Ben Davis, my co-organizer on this project, and I gave an interview last November and the interviewer from Public Radio International asked why—in the context of this project—we were taking these people on, referring to the titans of the computer industry. And I said, "We're not taking them on, we're just having them over."

One of the reasons that the Getty is interested is that we, too, are at a point in technological innovation when we feel the pull of high-end digital technology and are intrigued by its usefulness. Stewart, Ben, and I wanted to challenge the uncritical acceptance of this technology. Because in fact, instead of being a solution, it's more like a problem.

In many parts of the developing world, we're seeing the traditionally stately pace of progress go into warp speed, skipping over what we used to think were the natural steps of technological development. You all know of examples of places that go from no phones to cell phones in about a week, and it makes perfect sense.

The darker side of a leap into digital technology, though, might be reflected in the very real example of a Buddhist

36

temple in Korea, where a monk is transcribing very important religious texts from wooden tablets into digital form. And he's thinking that this, finally, is the safe way to protect these wooden tablets, this ancient and unique library. And he's not alone in thinking that, and assuming that someone is handling the problems of the survival of these records. The bad news is there's not anybody handling that problem. Yet.

Decisions to commit large sections of small budgets to digitizing projects are being made all over the world. Funds that might have been used to conserve the fragile originals are now being dedicated to these digital recording projects. So if the digitized record deteriorates, if the medium on which it's recorded deteriorates, and we've already spent all of the money we might have used for conserving the original record, then we lose twice.

It is important for all of us to understand the implications of committing these kinds of resources—human and financial—to these kinds of projects that may seal the fate of unique cultural records. Slowing the technology down is, of course, not an option. So we have to begin to close the gap between invention and responsible use.

We assembled this stellar group you see here for this brainstorming session. They were charged with articulating the problem or problems as they perceive them, and imagining what possible futures might look like, even on the darker side, and with thinking through some examples of special or representative cases trying to work through a few solutions, and perhaps suggesting a route to some forward progress.

With this as context, I'd like to introduce my friend, colleague, and co-organizer, Stewart Brand of The Long Now Foundation, who will moderate the panel session.

> ▶ **STEWART BRAND:**

Thank you, Margaret, and thank you to the Getty for helping this thing happen.

It grieves me as a technophile to realize how profoundly the computer digital revolution was snared in a delusion. Snared because it is so extremely useful, there are many things you can do with data in connection with people and cool special effects and on and on and on. It draws you into it. The delusion part is that . . . one of the things we've all been told is that once it was digital it was permanent. And people like Andy Grove at Intel have said, "Well, the great thing about bits is that they're permanent." And outfits like Corbis that record things, they figure permanently, by digitizing them.

Civilization now happens digitally. And it has no memory. This is no way to run a civilization.

STEWART BRAND

Brand

In terms of that example you gave of the wooden script, Margaret, I'm sure the wooden tablets will last a great deal longer than that rather expensive digital copy they made. Because the media that these were recorded on are so far very short-lived. Ten years is typical for CD-ROMs, magnetic tape, and things like that. Even if you can keep the zeroes and the ones in order, the things that read them move on, obsolesce.

One of the things that's happening now is people are starting to have personal experiences of early digitized records now being completely unreadable. And you think "Well, that's okay, you know, this is a revolution figuring itself out, I'm sure they'll fix it any day now." I'm sorry to say that one of the things that came clear in this discussion of the past two days among people who really know a lot about this field is that probably most of the digital, maybe all of the digital stuff that you know and care about now, is also doomed. Whatever it is. It is simply so deep and so varied a problem, that there's not a simple solution.

An example of this is that the 'Net is, you know, a great solution domain for all this because it's all connected, it's got these standards, all that sort of thing.

Brewster Kahle pointed out that one of the peculiar things about the 'Net is it has no memory. It's as if it's now the main event for civilization, right? We've made our digital bet. Civilization now happens digitally. And it has no memory. This is no way to run a civilization. And the Web — its reach is great, but its depth is shallower than any other medium probably we've ever lived with.

So you've got this peculiarity of these expectations being raised by this revolution seducing us to say things like "Boy, we finally got permanence covered by going digital!" The reality is lower than what was the case before—it's not permanent at all. And furthermore, it's not easy to fix.

What we've been doing the last day and a half is looking into what is the real scope, scale, depth, detail, and varieties of the problem. What we're going to do today (we mainly want to interact with you) is to give you a sense of ways to look at the problem, and, with the remarkable people assembled here, is to have several of us talk about parts of the problem that have made it so interestingly, importantly intractable.

I'll start with Brewster Kahle.

▶ **BREWSTER KAHLE:**
I work at two organizations: one is the Internet Archive and the other is Alexa Internet. Both are trying to understand

Kahle

some of the technology issues and the institutional issues in this problem domain. What I think we came to is our cultural artifacts, a large number of them, are now in digital form. The question is, What now?

And the first reaction tends to be, "Oh my God, it's all going away." And that's the film that you saw before [*Into the Future: On the Preservation of Knowledge in the Electronic Age*] and a lot of what we're all grappling with.

There's also this twinkle that comes up, which is, now that this is in digital form, we can do fantastic new things that we were never able to do before, in terms of making sense of it all, collecting it, data mining it, moving it all forward. If we really put ourselves to it. If we don't, it's all gone in 10 years.

I've looked at what institutions might change to be able to absorb this Internet and digital revolution that's going on right now. The first was the publishers, they've already been hit on the side of the head by this stuff that went from WAIS to gopher and now the World Wide Web. So we now have an infrastructure, but it's based on open interchange and copyright. It kinda looks like paper, like published stuff.

But the mean lifetime of a Web page is about 70 days. It just goes away, and there's no one behind it. The traditional role of a library is to stand behind the bookstores, the magazine stands, and taking care of publications when the commercial institutions are no longer interested.

Alexa Internet is about trying to organize the whole World Wide Web. It's collecting the whole Web and trying to impose some kind of organization on it. And we're trying to figure out what mainstream libraries should do. Another organization that doesn't quite know what to do are the archives. Look at the National Archives—they have about 300 gigabytes in the National Archives. That's what is generated on the Web about every eight minutes. So we've got the wrong scale of a solution in terms of archives.

To try to preserve it all. The Internet Archive is trying to collect the full copy of the Web and 'Net news. The sculpture that you see on the other side [of the stage] holds a collection of the World Wide Web in early 1997. It's two terabytes of information; the pages you're seeing are from 1997.

Another is museums. What role should museums play in this world? They've typically been an explanation device, an education device. What should the Getty do? What should all the different museums do in this Internet world? Where it's all distributed, so the people might be out there, or there's this digital material we're really not quite sure what to do with it. And one that we spend a while on are deep archives.

Deep archives are ones that last 10,000 years. And who's doing any of those? And we don't know of anyone. How do you build things that last 10,000 years?

Currently, our institutions really don't know how to adapt. And if we don't adapt soon, we'll go through a dark period.

▶ **STEWART BRAND:**

Someone who's been dealing with this problem up close is the archivist Howard Besser, who has a nice parsing of the problem.

▶ **HOWARD BESSER:**

Besser

One way to divide the problem is to look at it in terms of these five different areas: the viewing problem, scrambling problem, inter-relation problem, custodial problem, the translation problem.

The Viewing Problem is based on the fact that traditional formats and media (paper, stone, parchment), prior to digital, have always persisted over time, there was some way to read them over time, no matter what. We might need a Rosetta Stone to translate them or something, but even if someone did nothing, these things would last over time.

Digital information isn't like that. The bits will fall off over time if someone doesn't do something. But, even more than that, the file formats change. How many of you know what the best selling word processor a dozen years ago was? WordStar. Can any of you read a WordStar file? Particularly a WordStar file on an 8-inch floppy disk?

(laughter)

The kind of infrastructure we need in order to make these things persist over time is not just the actual codes, it's the application program, the peripheral devices, the storage devices. All these things combined.

That's a serious problem. And think about this with all the different file formats that we have. It just creates a nightmare.

Next is the Scrambling Problem. This is when in order to realize some immediate need, we start doing things that have long-term peril. For instance, for digital commerce, we're starting to develop container architecture for encryption, for storage and delivery, to answer those kinds of problems. We develop compression. All of these things add a level of complexity that makes it more difficult to try to keep these things alive over time or to go back and view a particular digital work sometime in the future. Particularly over a long period of time.

The next piece is the Inter-relation Problem. Increasingly, information is inter-related to other information. And there's a serious issue about what the boundaries of a particular piece of information is. How do we save all of that? Because things are now all a part of context; various types of information refer to other types of, or pieces of, information. How many of you have ever gone on the Web and hit 404 Not Found? That happens all the time because one particular information piece is linked to others. When we start trying to save something, how do we save that context? That's a serious issue.

Next is the Custodial Problem. This is how do we decide what to save? Obviously, we're not going to save everything. Who saves it? Obviously, individuals save it, various social entities, organizations are responsible for saving it, but how do they save it?

Currently if someone wanted to save something, we don't have a prescription of how they would do that. Think about the important other pieces to that, such as saving the authenticity of a document, or the evidence that proves in fact that this was the entity it's purporting to be—archives typically have a chain of custody. Think of the famous hoax of Piltdown Man. We can start having those kinds of things creep in if we don't have some way of maintaining evidence over time.

The last piece is the Translation Problem. If we save things over time, and we try to play them back later on, a serious problem arises when they're translated into different devices that can not possibly replicate what happened before.

For instance, many people would contend that a video of a film is not the same as that film. But that may be what persists over time. We're missing pieces.

A lot of this has to do with context, but a lot of it has to do with what an object actually does. We can save the full text of a book, for example, but will we save the page turning behavior as well?

► Stewart Brand:

The ablest inventor and designer I know is Danny Hillis. Among other things, he created the current generation of supercomputers, massive parallel processing. And he's been helping us, because one of the ways you be a good designer is to look at the design problem in a structured way.

► Danny Hillis:

Seriously, I'm going to look at this in a constructive way as opposed to everybody else who are looking at it in a destructive way . . . (laughter)

What I'm going to talk just a few minutes about is trying to get some handle on the scope of the problem and the piece of the problem we might want to attack first.

We're very fortunate that civilizations thousands of years ago recorded things on media like stone tablets that lasted for thousands of years. And we're fortunate that people hundreds of years ago recorded things on acid-free paper that lasted for hundreds of years. And I suppose by the same reasoning, we're fortunate that people 10 years ago stored things on media like magnetic tapes that lasted at least 10 years. So we can still solve this. But our good fortune is running out.

And this extrapolation, I actually believe, is leading to something I call "The Digital Gap." The historians of the future will look back and there will actually be a little period of history around now where they really won't have the information, they don't have the correspondence between world leaders and great scientists. They don't have the actual raw data of the great scientific experiments that are done. They don't have the music that was written during that period. The art that was created during that period. Because we're in a period now where we are storing things that will not last even our own lifetimes. And that's really the first time that the basic creations of civilization are being stored on media that won't last a lifetime.

Hillis

So the digital gap will span from the widespread use of the computer up till the time we've solved this problem. So I think a lot of the definition of what we're trying to do is shorten that digital gap and our history to be as small as possible.

We talked a lot in the conference about various dimensions of difficulty of this problem. Here is a graphic of just a few examples of dimensions of difficulty that we'd talked about.

For example, in the most difficult version of the problem, you would store everything. In the easiest, the easier versions of the problem, you might store only the most precious things. Obviously, the less you store, the easier it gets.

We're experimenting right now with the digital, the difficulties of electronic artifacts. Okay.

So, for example, one of the examples of dimensions of difficulties is, how much do you store? Do you attempt, for instance, to store everything on the Internet as Brewster is doing? Every television show or ad that gets broadcast—of course that would be very interesting presumably for an historian. It's very hard to guess what is going to be interesting.

> *We could at least give them a tool so that they could store their bits in the digital equivalent of acid-free paper.*
>
> DANNY HILLIS

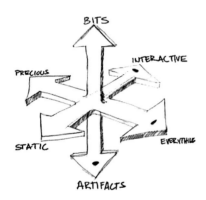

Looking back, people have a very bad history of figuring out what's going to be interesting, so if we look in the pyramids, the stories of the battles that were carved in hieroglyphs officially are probably less interesting than some of the graffiti put there by the workers on the inside. But, certainly a lot easier if we take things that people believe are precious.

Another dimension of difficulty is where do you store the information? For example, if I store the text of a book, that's not really the same as storing the book. I mean, I'm not storing which pages were worn, I'm not storing the idiosyncrasies of the font. So there's a sort of continuum between storing artifacts on one end and just storing straight bits on another end.

Another difficult dimension is: What's the nature of what we're storing? Is it a static document, which is relatively easy, or is it some interactive thing like a computer program? For example, SimCity probably is of some historical importance in the history of simulation. It's a computer game. But to store that, storing the bits of that program is not enough. You have to store enough information to go back and re-run that program, display it in the same way, and so on.

So, we thought we would concentrate first on the easiest of all of these dimensions. Consider this quadrant up in here, which is relatively static information like documents. We've chosen particular things to store that we think are valuable. And we're only going to store the bits in that, we're not trying to store the artifact. So that's the simplest version of the whole space of this problem.

And even that's quite difficult. But if we solve that problem, we felt like we'd have a tool for approaching some of these others. So I think one of the decisions that came out of this was at least an interesting subset of the problem — to come up with something that might be the digital equivalent of microfilm for a library. For someone managing a library, a corporate archivist, that was an individual that had particular information that they cared about. We could at least give them a tool so that they could store their bits in the digital equivalent of acid-free paper. And we would give them at least a medium to do that with.

Now, the question is, How long are we trying to solve this problem for? That's the one dimension in which we decided we'd try to pick the hard problem. We believe it's possible to come up with a medium in which you could reasonably expect to store something over a millennial time-frame. At least to store the bits over a millennial time-frame.

And that certainly fits well within the sort of time-frame of our own civilization and our own historical interest.

But that raised the problem of where you might store the bits, and whether we have the ability to interpret the bits after that much time.

So I think one of the problems that we identified—a sub-problem—was technological: can we generate an inexpensive medium that lets you store bits over long periods of time?

There's a much more difficult cultural institutional problem of how to ensure that the meaning of those bits gets maintained over time; that language in which it was written gets maintained. We had some ideas about that.

Those are two problems that we focused on a lot. And I think some of the other speakers will talk about some of our partial solutions to them.

▶ **STEWART BRAND:**

Thank you. Peter Lyman is also an archivist working at the library at UC Berkeley and has some familiarity with the nature of some of these kinds of bit documents and their value.

Lyman

▶ **PETER LYMAN:**

I'm going to talk a little bit about the scale of the problem, particularly from the point of view of a university librarian.

I talked to Terry Sanders at lunch and asked him how the reaction to his film *Into the Future* had been, and he said only now did he realize how conservative he had been in stating the problem. That having made the film, the letters and e-mails he gets from around the country have convinced him that the problem is much more severe than he thought when he made the movie. That in retrospect, although he called the movie the equivalent of Rachel Carson's *Silent Spring*, perhaps the problem as he hears it from other people is much worse.

I've been thinking about what we might want to save. As a librarian, I know we can't save everything. In fact, we save things that we think are useful to scholars. Here's a list of some of the things that are disappearing. A friend of mine, a sociologist of knowledge, says this is the first time since the 18th century where genuinely new ways of representing data are being invented.

The pie chart, the bar chart, and the histogram were all invented in the 18th century. And one of the most striking

digital documents is not just visualization of data, but data collection itself. Data collection from satellites, from things that roam around the body and the universe, collecting data and then letting us see them in new ways. I love interactive molecules in which you can change the standard temperature. I think there ought to be one in the Getty collection as a work of art that is incredibly distinctive for our time.

So scientific visualization and data collection are distinctive for the late 20th century—our distinctive invention, but it will probably not survive with the Web, the Web which Brewster is archiving in the Internet Archives. There are quality control problems, and organizational problems, but would any of us say that a historian of the future would not want a representation of the Web? As a representation, let's say, of popular culture. Perhaps the equivalent of the age of pamphlet printing at the beginning of the printing press. And certainly because it has enabled global communication. It has transcended boundaries.

Software. SimCity is in fact something I discovered driving on the Pasadena freeway. As we exited into Pasadena, the Arroyo Parkway, my eleven-year-old daughter said, "You know, I wouldn't have put the power plant there, I think I would have . . . "

(laughter)

. . . because she was mentally reorganizing Los Angeles as an eleven-year-old because she grew up with SimCity.

Now one of the definitions of a work of art is it's something that transforms your perception of the world. SimCity by that standard is a work of art. It should be, by the way, in the Getty.

(from the audience — laughter, and "We need another building!")

Medical imaging. Many of the breakthroughs in medicine now have to do with data collection and imaging. I have a personal sense of the urgency of preserving this accurately in my own case. I imagine each of you does in your case. Well, who's thinking about it globally?

Many organizations now have chief information officers, the nation in fact collects the census in digital form. Believing—in fact, it's in the Constitution—that the census is one of the ways in which the nation reflects upon itself. So our identity has to do with the survival of those kinds of artifacts.

And finally, we're not just talking about digital. We're talking about signals, I think. That when we think about this problem, think about television and radio. Things that are probably only preserved passing by Vega, you know, if you

get out there in a spaceship you might still be able to collect early television and radio. I think we'd all agree that these things are essential to our understanding, and indeed, the management of our civilization.

But out of this list, as a librarian, I have three problems I'd like solved by 10 or 15 minutes from now.

The first is the one Danny just mentioned. When we know a book is important, we know what to tell a publisher, print it on acid-free paper. And under a decent library air-conditioning and so forth, it will last 500 years. If you want to preserve something else on a piece of paper, like a newspaper, microfilm it. We know that there's a 500-year life to microfilm, properly cared for.

Well, what do we do with digital documents? What we do today is we refresh them every time there's a change in technology. Or every 18 months, whichever comes first. This is an expensive strategy, so we need, as Danny said, a digital equivalent to microfilm: 500-year solution.

Secondly, as Brewster said, the institutions that have grown up responsible for the archiving of paper—libraries, archives, museums—have grown up around the characteristics of paper. What are the institutional equivalents—organizational strategies related to managing the new media? Funding mechanisms that can be responsible for organizing something as complex as what Howard described. Things that linked, perhaps globally.

And thirdly, we need an intellectual property regime for digital documents that respects the idea that there's something other than their current market value that's important. That a balancing good is an intellectual property regime that allows us to copy them in order to preserve them.

Those will all be solved by the next speaker. . . .

▶ STEWART BRAND:
. . . who is Kevin Kelly. Kevin is Executive Editor at *Wired*. And he gets technology in his face up close and personal. And all the opinions about it.

▶ KEVIN KELLY:
And I will not solve the problems right now. Tomorrow.

There are lots of exciting things about digital technology. They're reminiscent of the invention of paper, as Peter has talked about, how paper and the invention of printing were made through the scientific correspondence, the scientific journals which were very important in creating science, than

Kelly

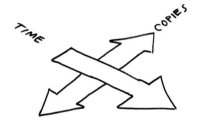

libraries which are very important in creating a literate culture. And paper did that because it had some certain qualities which I want to show.

The interesting phenomenon of paper is that while it was very difficult to make copies of in space, it was very easy through time in the sense that it stayed, you didn't have to make a copy. It traveled through time very well, but it didn't travel around the globe very well. Now, we come to the digital era and the immediate first euphoria that we had about the digital world was that it did something different.

It did this: It made copies very easy to spread throughout the world. The Internet is basically the largest Xerox machine in the world. If something can be copied it will be copied. On the Internet, it goes everywhere. But what it doesn't do is it doesn't go forward in time very well. So that's the problem that we have. Things laterally copied, but not forward into time because they rot in bits and platform drift and all that.

So what we're looking for is something in between that does pretty good copies laterally and pretty good forward movement through time. And one of the things that we're thinking about, at least I'm thinking about, is ways that have some of the attributes of the digital world and some of the apparent attributes of what we think of as atoms or analog. As a technical leap, we could begin to think about that and imagine an event that has both of those characteristics.

We as a group talked about some initial ideas about ways in which you can make an object, an artifact, a vehicle, a medium that contained both some of the qualities of digital information—easily searched and cataloged and copied with the persistence and actual legibility and transparency that a book has.

There are lots of problems with that, but one of the things that we decided that we probably want is to have something that when you pick it up it was a digital copy, but in fact, you could see it, you could read it at various levels, you could see something about what it was. And maybe even with an optical microscope begin to examine it so that you could read it, perhaps even just with your eyes. And a simple microscope if you had to, as well as electronically. So that's the a kind of thinking that I think needs to happen right now. We're not stuck just with the kind of digital technology that we have, we can do something like books, but not like books; something like a CD-ROM, but not like it. And that's sort of the technological challenge that I think we can begin to go on.

► **STEWART BRAND:**

It would be pathetic if a bunch of bright people came together on an interesting problem and came away at the end of the meeting saying that is a really interesting problem.

(laughter)

Seriously, we did try to identify some avenues of early and encouraging solution with the idea that where optimism goes, activity might follow. And to talk about that is Doug Carlston, who is chairman of Broderbund Software.

Carlston

► **DOUG CARLSTON:**

Yes, we did find the solution and I have it right here. (laughter) And I'm authorized to share it with you.

Now we did decide it was better to solve something than nothing. If we couldn't solve everything, you would probably forgive us. So we decided to narrow it down in the manner that Danny talked about. Try to solve the problem of a limited quantity of something valued by somebody as precious in a relatively static environment and save the bits rather than try to save the entire context.

And that itself is a trivial problem for the reasons that many of the people have talked about already. There are three aspects to the problem. You have media that are relatively short-term, you have perceptual devices that create a problem going forward—digital disks cannot be read by the naked eye, at least I can't. That means that if the technology changes dramatically, you have to create a context, the means by which you translate that into something that can be viewed by a human and make sense. And then there's the interpretative level that we talked about. You have to not only see the bits, you have to figure out what they mean.

And I'm explaining this because we came up with a "solution"—please take that with quotes around it—that might on the surface seem a little bit complex, but . . . it's the best we could do in a day and a half. And I think it does deal with the inherent problem of preserving the bits as well as preserving the meaning.

The way we posed the problem was we wanted to create a prototype project, a system that would preserve both content and meaning for a millennium of some body of valued knowledge. We didn't spend a lot of time focusing on what the knowledge base would be. Maybe the Getty would like to give us a list of what they think are the 10,000 valuable books in the history of mankind and that will be our canon for this particular prototypical event.

We will include some additional things to that canonical literature. We will include a Rosetta Stone, something that

has all of the human languages in a form that creates enough equivalents that somebody could parse it if English is no longer a viable language. There would be, as Kevin showed, a visible instruction set that would tell you how to get into the data, provided you could read the instructions.

And then we'd split what we're doing into two components: one intended to preserve the meaning, its contextual meaning, and one that essentially would serve as a standard to the bits, to prevent what we call "data drift," or "data creep" over time. And you might think of these as two kinds of races. The first, which we call the relay, essentially is using current technology in developing a process of which the information is kept in digital form. A 10-year life expectancy. It is recopied within every 10-year period. It is disseminated broadly on the Internet. So anyone who has a vested interest in that content can possess it. And so it is kept alive. It is annotated by people who care about it, it's recompiled if it involves different word processors, different machines. It is used. It's reviewed. It's exercised, if you will.

The problem with that as a total solution is simple. One is you don't have a central authority for the original meaning. You do get data creep over time. If you've got a thousand copies out there and everyone is changing it slightly over time, it's very easy to lose the original intent. At the same time, you're keeping it usable by people who do care about it.

If you have a single archivist whose responsibility is to be the sole holder of that data, and there's a lot of proprietary data that would fall under that format, the problem with having to recopy it every 10 years is you dramatically increase the probability that a single error by the archivist—a single broken link, breaks the chain permanently. And the risk is far greater than when you're dealing with acid-free paper that has a shelf-life of 500 years.

So we're combining this with a second half. A second half might be the marathon. This is essentially creating a hard copy. Very "retro" approach. On some very permanent material, maybe mylar, metal, optically etched—albeit a very fine scale, so that with a conventional optical microscope, somebody could read it. This would serve as this, would not be used, this would be put away in a well-known place. There might be more than one copy. But it would be the standard against which the evolving textual content could be compared in case of disagreement as to what had happened to it, where it had gone. That will help preserve the bits, particularly if you find a place that's well-known that serves as a repository for the archive. What it doesn't do very well is preserve meaning. An example, if *Beowulf* were just dug up

right now and it hadn't been in the literature for a long time, understanding it would be very difficult. What you need is an evolutionary approach toward the content that allows people to add to it, to understand it, to interpret it locally so that you have a process that stays with it—that becomes a part of that historical record over time.

Essentially, by keeping these two at the same time, one broadly disseminated, one not necessarily, but as a standard against which the broadly disseminated copies can be compared, I think you start to address the weaknesses that each one of these systems has independently.

Does this make sense? I don't know, and certainly it depends on how valuable you feel your data is. There's costs involved with this. It's a process that I think if we can take it through prototype and do it one time, it can easily be recorded and made available for people who have their own idea of what's valuable if they cared to preserve something for a millennial time period.

It is, incidentally, this group's intention to do this. This is not a purely intellectual exercise. And we will undoubtedly be soliciting opinions as to what those 10,000 great books should be at some point in the near future.

▶ STEWART BRAND:

Talk about world-saving. Phew! Civilization is safe! And you know, it's true, that's what it takes. Getty is in that business and here from the Getty, one of our hosts, is Ben Davis from the Getty Information Institute.

▶ BEN DAVIS:

I'll be brief. I just wanted to thank Margaret and the Conservation Institute and Stewart and The Long Now Foundation for asking me to collaborate on this problem.

When Brewster suggested bringing his sculpture up here, at first, we went "Uh, oh." Bringing a sculpture into the Getty, how do you do that? It arrived in that huge rainstorm last week and we were, the other dimension to it was, "Oh no, I hope it didn't get wet because it's computers." And then when we were moving it, the guy that helped us move it, I said, "You know what this is?" And he said, "No, what is it?" And I said, "It's the entire World Wide Web." And he looked at me and said, "I thought it would be heavier." (laughter) It's a lot heavier than it looks.

One of the problems we've always had (AHIP, now called the Information Institute) is explaining to people what we do. And because we work in this bits world, things are

Davis

not heavy. They don't have mass. They're moving targets and they're so multi-dimensional as to be sometimes very difficult to articulate. And I think it's part and parcel of what we do here at the Getty, which is we deal with human expression. And the longevity—we made a list of things that would survive 10,000 years and one person mentioned that people would be interested in history, and I thought, "Well, hopefully if they're still humans, they'll be interested in human expression."

And human expression has so many dimensions. It's one of the unique problems I think we have with cultural information and bits is that all those issues get more and more complicated because of the nature of the information. It has been said, also, and this is my little segue, that all art tends toward music and that we're very, very happy to have Brian Eno here, whom I would much rather hear than me, so I'm done.

(laughter and applause)

Eno

▶ **BRIAN ENO:**

Since I'm interested in cultural objects, the question that most interests me is: What is the difference between preserving data, with things like tax returns for example, and preserving cultural objects? Obviously, we're going to be working all the way along that spectrum. The difficult end is the cultural object.

To give you an example of a cultural object that's extremely difficult to store in digital form, there's a painting by Kazimir Malevic called *White on White*, which actually looks just like this (holds up a paper napkin). This is actually a perfect copy of Malevic's *White on White*. Now can you imagine in 10,000 years time you'd finally dig deep down into the sub-strata and you opened it up—whatever it is— and you see that. It is absolutely meaningless without some sense of what it was a gesture towards. A lot of art objects, and in fact, a lot of cultural objects all together, are not just art objects, but things that people wear, things that people say, the types of behaviors they have, the wink that's worth a thousand words. You know, the wink at the right moment, which everybody knows what it means, but it's much too complicated to explain.

In fact, I would contend that most objects of culture are very much like that, they're embedded within context and those contexts are embedded within other ones as well. So a characteristic of cultural objects is they're increasingly context-dependent. And they're increasingly embedded in meta-languages. This is a difficult problem because it probably

Eno's representation of Malevic's
White on White

ROSETTA STONES

means that you'll end up storing tax returns if you're not careful, because that's the easier thing to store. I don't say that this is a problem that we're going to solve now or soon. But I think it is the really hard problem of what we're doing.

You have a Rosetta Stone—here's a facsimile of a Rosetta Stone actually—that is a perfect copy of a Rosetta Stone. One of the ways you can store complex objects is by cross-notating them with other ones. By showing what their relationship is to a whole nest of objects and so our storage systems. Ultimately, if they're aren't going to just be tax returns, we'll have to have rather complicated meta-languages attached to them. And we'll have to have, as Danny says, the possibility of growing those languages in time as well. So that we might store the hard copy of it as Doug described, but in fact we will somehow allow it to grow. Things will become added to it. Commentaries, interpretations, just like the books of old, such as the *I Ching* and other religious documents.

Just one more thing I would say, there are two styles of storage. We've talked about the rather "precious singularity" type. The other type is multiplicity, the pop record that is distributed so widely that something is likely to survive at the end. So we are trying to play both ends of that spectrum. And temporarily what that will mean is piggy-backing on the Internet.

▶ **STEWART BRAND:**

We're missing from the panel Jaron Lanier, who has been with us for all the discussions, but had to leave before this event. Years ago, Jaron did a game called "Moon Dust" which many people loved, but like everything else as an early personal computer game, it evaporated pretty quickly. Recently a museum asked him to please provide Moon Dust in a playable form. And he labored and heaved for months trying to put together a Commodore 64 from then and the right software, and all the rest of it, the operating system, blah, blah, blah. And he failed.

But then someone contacted him on the Net and it turned out that there was one of those special interest groups—David Byrne calls them "hobby tribes"—oriented around Moon Dust. And they had gone to the trouble to create emulators that could run on Macintoshes and PCs, which could pretend accurately to be a Commodore 64 from then and on which they were playing a pretty good version of Moon Dust. So I think the hope here is the Net.

Lanier

► **Brian Eno:**

I think one of the things that's provided for here is that we're trying to invent a way of saving things. We're not actually trying to be the deciders or the curators of what gets saved; the hope is that once a procedure is invented, then any interested group can raise whatever money is necessary to use the technology, and do that saving. So we hope that this nationalist issue wouldn't become a problem. Of course, rich people are going to be able to do it easier and sooner and in more detail than poor countries are. But that won't be an editorial question so much.

► **Doug Carlston:**

If I could add just one other thing to that. One of the problems with long term digital preservation has been cultural imperialism. There have been overt efforts throughout history by people to erase or alter the histories of other peoples, or eliminate the histories of other people. You saw it not too long ago with the intentional bombing of the library in Sarajevo. One of the things that I think the Net holds is that promise of an ability to proliferate information beyond the scope of that kind of what's usually local government-organized cultural imperialism, or at least in the world as we know it today, you can still probably put information beyond the reach of most of any particular culture's enemies.

► **Peter Lyman:**

We are a primarily technical group here, which is why you see the attention to technical issues, though there are some issues that have come up in the legal area. That as we move from paper to digital form, we've run into some issues. Where things are moving from copyright to licensing and this licensing—if you actually pay attention to them—means you can't keep them. So it's often illegal to create an archive. As I understand, some of the interest behind Hollywood changed the laws in the mid-20th century to make it illegal to create libraries and archives of, say, all of television. So there's specific things in the political domain that I think can be helped by having some idea that it's valuable to save this material. And it will have to be replicated in different institutions, in different governments. And who knows, maybe in the future the only law will be Internet law. But right now, that's not the case.

► **Eric Doehne, Getty Conservation Institute:**

I am curious about the issue of as these data losses continue to mount and we have more and more personal

experiences of this problem, do you expect that this might create a backlash, particularly in conjunction with the year 2000 problems, etc? And would that backlash against digital technology, favoring perhaps atoms in some respects, exacerbate this problem or actually generate some political will to solve this problem?

▶ **KEVIN KELLY:**

I think there is—even at this moment—a kind of a digital fatigue with the pace of things. There are people sitting up here, for instance, who refuse to upgrade to the next platform, or surrender to certain technologies in our own lives. So I would expect that to happen more as the pace of things increases. I think there will be a backlash, but one interesting thing about it is that it's actually very difficult to put into practice. You can struggle against it, but to not be involved or to be a genuine Luddite against it is very difficult. There is a feeling that atoms are safer, books are reliable, this stuff isn't, let's not use that. So I think that's a real phenomenon, but I don't think that it's necessarily going to feed into the solutions to this. A better way is for the people involved, like ourselves in this circle, to actually be ahead of that. To begin to identify the problem, to try and measure it, to talk about it. To offer solutions so that we're ahead of that backlash.

▶ **BRIAN ENO:**

There is a backlash going on. I notice it a lot among musicians. The music world has bifurcated into two completely separate camps who have hardly anything to do with each other. It's computer based music and the rest. There are very few people working in the cross-over area in between.

One of the problems is that when digital material corrupts, it corrupts absolutely. We've been used to analog materials that deteriorate rather gracefully. You know, a tape played over and over again does lose high frequencies. But you can still tell what the music is, you can still hear the song.

What has happened with some of my earliest digital recordings is that they have become absolutely silent. There's nothing there at all. A lot of people are finding that in all sorts of ways they prefer the type of deterioration that characterizes atoms to the type of deterioration that characterizes bits. The backlash is partly realizing that this problem exists.

▶ **ERIC DOEHNE, GETTY CONSERVATION INSTITUTE:**

I'd like to follow that up briefly with Danny Hillis. One of the prize jewels is, say, *Snow White*. And I'm curious how

Disney's preserving that currently, and whether or not you imagine Disney preserving this etched on aluminum plate as you're proposing.

Danny Hillis:
Disney has no better solution to this than anyone else. Right now, of course, we preserve *Snow White* as atoms. I certainly agree with Brian that digital material has the property of degrading suddenly and so on. I don't think that's fundamental about digital material. I believe that fundamentally digital storage could and should be better in almost all respects than analog storage. It has the potential to be better in almost all respects than analog storage. And I'm convinced that with some slight technological developments, a medium could be developed that's appropriate for storing things over a millennial time frame in digital material. And when that's developed we will store *Snow White* on it. It's a very important problem, of course.

The reason that it hasn't been developed so far is that it runs counter to the notion of digital culture almost to even think about the problem. The digital culture has been very much a short-term, fast, quick culture. Everything, product cycles are done in a rush; two years seems like a very long planning period for a high-tech company. Longevity has not been high on the list of things people have worried about.

So, for example, there's really no material reason why CDs degenerate in a couple of decades. But nobody's given much thought to not making them do that because what they're really worried about is that the particular CD format that they're coming out with is going to be obsolete six months from now. The real problem is not technological. We have the technical understanding to solve the degradation problem that Brian is worried about. What we don't have is the culture of long-term thinking that supports that.

We're talking about a symptom of a deeper problem in society, particularly around high technology.

When I was a kid, growing up in the 1960s, people thought of the future as the year 2000. And now it's 1998 and people still think of the future as being the year 2000. And so it's like the future has been shrinking one year per year for my entire life. And this has got to stop pretty soon.

We're obsessed with the end of the millennium, the end of history, the end of economics. You can get a best-seller book by either putting "The end of" or "The last" in the title. It's just a little phase we're going through. It's coming from the millennium, but it also happens at a time of profound

transition to an information society—in a very short period. Things are changing very fast; we don't believe in the future because we can't imagine it.

So we don't make plans for 50 years from now or 100 years from now because we basically correctly believe that we can't imagine what 50 or 100 years from now is going to be like.

The backlash I'm looking forward to is the backlash against short-term thinking. I think there is going to be some time in the early 2000's when everybody wakes up from their hangover from the big millennium party and people realize that we're not at the end of something—we're at the beginning of something. And there really will be a year 3000 and 4000 and so on. What The Long Now Foundation is about is getting ready for that new backlash toward the long-term. And trying to encourage people to believe in that long-term future. And I think that once that idea gets more deeply into society, then you'll find that the people who, the engineers who are thinking of the next medium will naturally think about, "does it last and what happens hundreds of years from then?" and so on. And then these technical problems will be solved.

▶ Peter Lyman:

It's interesting that Terry Sanders described his film as like Rachel Carlson's *Silent Spring* and I think Kevin, in our discussion, noted that our current situation is like the beginning of the environmental movement. It's hard to scale the problem, what we can do is try to create an awareness so that people would begin to define it. Part of this is something Howard and I talked about a lot in doing the background paper— which was to begin to think about the sustainability of information. And some of the things that endanger the sustainability of digital information are quite fixable.

▶ Audience member:

[To Brian Eno] As you create these icons, they become annotated and modified, particularly I'm thinking of your work, at what point do you become not the creator of it? As an artist, you create something, at what point does it become somebody else's work and you're just a participant?

▶ Brian Eno:

Well, fundamentally enough, that's a question you can always ask anyway in mass media forms, because whatever

you make is being planted into a culture which is already rich in references to it. So I don't actually think that changes radically.

► SAME QUESTIONER:
Even though that there's so little difference, in a digital medium you can make the change and it looks like the original.

► BRIAN ENO:
But what we're talking about is not evolving the original, we're talking about keeping the original and adding layers of annotation, you might say, to layers of commentary to it. So it's slightly different from a generative process where you plant a seed and it turns into something else. We want the seed to stay intact as well.

► AUDIENCE MEMBER:
I was wondering how much your discussions focused on the need for bringing public and political will behind preservation. That the preservation has a technical problem but it has a much larger problem having to do with usage and dependence. And the environmental movement is probably a pretty good example as more people had less clean water to swim in and to drink, the political will ramped up and the demand for preservation increased because of the recognition of increasing dependence on fewer resources. And as you talk about preservation, where were your thoughts going on until digital bits and bytes are seen as a resource necessary for survival by a larger and larger group of people. The political and public will or the multiplicity that Brian referred to a little bit, I think, won't be there to support your efforts by saving and creating things and the political pressure to save them.

I just wondered where your discussions went beyond technical issues to a recognition or a grappling with the public and political need and demand.

► STEWART BRAND:
Your question makes me realize that we may be grateful for the year 2000 problem, in the sense that it alerted to us how much our civilization is now dependent on the bits and bytes and that they need to be basically safeguarded in very fundamental ways. And if you make mistakes made in haste, such as using two digits instead of four, for the year date, and you let that become deeply embedded in layers and layers of

code, then you can have things like planes running into each other and financial collapses and so on. Which, if the year 2000 problem had not been addressed, would have occurred. And we may still get pieces of that. So it's a very interesting and productive panic, I think, which has developed around that one.

► **BREWSTER KAHLE:**

We're early in this. I think actually what's exciting about this is only now are we starting to get groups of thinkers together to try to figure out is there a problem, what is the problem, what should we do. This is exciting in its own right. But I'm not aware of a lot of discussions about this a couple of years ago. There are a few people crying over not being able to read the old MIT and Stanford artificial intelligence tapes. But these were sort of small pockets of folks . . . We're early on.

► **BEN DAVIS:**

One of the other things we're doing is our Web site for Time & Bits [http://www.gii.getty.edu/timeandbits] that we will continue using. One of the things we've started to do on this is collect stories of digital disasters; people are sending us their favorite examples.

► **HOWARD BESSER:**

We made a very clear distinction between the problem of storage and the problem of preservation. The problem of preservation clearly has a will and a political component. We started talking about some of the pieces of that, including some very real tractable kinds of things like intellectual property law and changes in that. We did discuss how we can try to bring together certain relevant parties to try to draw more public attention to the problem. And in fact, having you all here is a way of doing that.

► **BEN DAVIS:**

We'd like to convene other meetings to involve legal people and business people and government and science people. The importance of the problem is gradually dawning on these communities. We would take the people from this panel and plant them on other panels to keep a continuity of discussion going. So this is a digital vehicle you see up here.

► **ROBERT ROSEN, CHAIR, DEPARTMENT OF FILM AND TELEVISION, UCLA:**

In reflecting on the comments here about what policies to recommend to move forward, a particularly useful distinction that's been implicit in a lot of the comments—but I'd like to see it foregrounded—is the one between preserving what is digital and digitizing in order to preserve.

In the first instance, it's clearly a clarion call to action. In the second, it's got mixed in with it some cautionary notes about what not to do. And maybe first to avoid premature action. Speaking as a film archivist, the comment that was made that the films at Disney are being preserved on film is very reassuring, but the history of the industry has been very full of short-term decisions made based on short-term economic concerns, and a price has been paid. The number of films that were transferred to video because the assumption was we won't need film anymore. Really tragic. So I think, as one makes recommendations to move forward, the recommendations of avoiding premature closure, of looking in a very cautious way about protecting originals, particularly when they're works of art and where the original is what it is. And that a replica of it will never be the same thing would be a very useful thing to work in. I wonder if anyone wanted to comment on that.

► **HOWARD BESSER:**

I do a lot of consulting for people who are doing digitizing projects; to digitize something purely for preservation purposes is not a very good idea unless the actual original is not going to last very long—brittle books, for instance; or unless you have solved this problem of being able to keep it safe in digital form for a prolonged period of time. Digitization projects for preservation are really digitization projects for access; their objective is to preserve the original by having the access go to the digital copy rather than to the original.

► **DOUG CARLSTON:**

If you remember Danny's graph, where he went from artifact at one end to bits at the other, you have to take everything and put it on that chart. The benefit of digitization obviously declines the closer you get to artifact. There's far less value in digitizing a portrait gallery here than there is in archiving great books, where it's the intellectual content or the bits that have most of the value. There's some value in publicizing artwork and having it in reproduction form, but it would never replace the originals in terms of value.

One thing came up for me this afternoon about coming from an emotional perspective. I can take the example of music, where there are a few schools of thought about CDs. I grew up in the 60's when we had records instead of CDs; many people now that say CDs are wonderful because they reproduce the music so well. But there's another side to this; I remember being surrounded by sound from the record format—surrounded by it and it resonating from inside as well. This is a very difficult thing to talk about, but I think where I'm coming from is a desire for a backlash. It just makes me feel sad . . . it's a loss that leaves a sadness or wanting to grieve.

► **Brian Eno:**

Well, you'd probably be surprised that among us, there are more faithful analog listeners than digital listeners. I know Jaron Lanier is a very committed, what do you call it? "Analist?" (laughter) Probably not that word. Analog-ist? And the other thing that I notice among practicing musicians is that they keep buying more and more analog equipment.

We've been having a conversation about this recently, because they're in technology at the moment, certainly music technology, which has traditionally been a good indicator of what people do in technology generally. You have two really distinct trends going on: one is towards new instruments with thousands of new options, which is what synthesizer design is about, and the other is towards either rebuying or recapitulating old instruments that have very few options, but with which people have very strong rapport. You know, the thing that makes a violin still a viable instrument—it's pathetically limited as an instrument, you know it's got four strings, you know, I've got synthesizers that cost 150 pounds that have 5,000 sounds in them. So how can a violin compete? Well a violin can compete because people have a relationship with the violin. And there's a long history of human relationships with instruments like that.

So I don't think you need to grieve too much. I think that those things won't go away because there are conversations that our culture still wants to have and will want to have for quite a long time.

► **Ben Davis:**

During a dinner conversation with Brian we talked about this; the other notion is that digital technology is really allow-

ing us to understand the emotional content of the analog of our world. And that's an appreciation that's oddly enough heightened by the rigidity or coldness of digital music in particular, but it's a curious thing that I think we'll probably appreciate our analog, continuous fuzzy world a lot better because we've had this other experience.

▶ Danny Hillis:

I have a different definition of technology than Alan Kay's, which is, technology is the stuff that doesn't work yet. (Laughter) There was a time when the violin was technology. And in fact, what we're dealing with is that digital technology has proved so useful that we've starting using it before it really works. It has certain features that are so compelling, like the 5,000 voices in your instrument that you're willing to use it even though the interface to it is crude and probably won't be able to compete with the violin until, you know, for another 200 years of refinement. I guess I hold a lot of hope for the long run. I don't think this is a characteristic of digital, I think this is a characteristic of some new stuff that we haven't figured out yet. And so my guess is that over the long run it's not that everything has gotten worse and will be worse in the future. Nor is it that we'll go back to analog.

In fact, I think that over the long run, we'll learn how to use these new kinds of artifacts, refine these new kinds of artifacts and put in them the kinds of things that makes us love the old kinds of artifacts and the kinds of things that make us make the connections, all kinds of artifacts.

▶ Howard Besser:

How much of this is just a question of too much information and problems with trying to collect it all? And not giving history a chance to pull what's important up into some sort of place where it can be saved? What you said, Stewart Brand, about the Internet is wonderful. This mass of information. But it has no memory. And I argue that it's the reverse, that while the Internet itself has no memory, what drives the Internet is the people out there. And they're the repository that's the memory and they actually may be the solution to this problem. And I bring a goofy, pop-y type of illustration which is Pong. Pong was made on this computer that you can't find anywhere. Much less find one that works. But you can get on the Internet and you can get a copy of Pong that will work on your computer today.

So I wonder if we're, I don't know, maybe with all the information out there and all the ways that it's useful we want to collect it all. But, we're not going to be able to and the multiplicity of the Internet will solve this problem.

▶ HOWARD BESSER:
The issue is not trying to save everything. No one is advocating that. The issue is that without concerted action, we're probably going to save nothing. Or very little. And only a very, very, very tiny amount of what we have today will persist over time. And only perhaps for very short periods of time because people actively exercise that and convert that as some community did with Pong.

▶ BRIAN ENO:
I'm sympathetic to the suggestion that we are subverting the natural process of cultural memory, in which forgetting is as important as remembering. The only proviso here is that it's as though we've built all the castles of our recent history on sand. So there isn't even time for that process to take place. This is perhaps all we're talking about, this little window here. Even if you want to remember it, even if that ecological process you're talking about wants to take place, it might not be possible because the stuff will have gone already.

So this is a special period. I think it's different from, you know, a period of vinyl or analog recording tapes. It's I think relatively easy to see how those eras can either be recreated or the materials (because they degrade rather gracefully) can be at least recalled. But this little period is different.

▶ STEWART BRAND:
I think there's a question we found coming up a lot of times is that there's a version of information overload which is a common term and common anxiety people have now. Which, if this group is successful, you can add to it "past overload," where everything is kept and access to it is managed; it's not only stored, but it's preserved. It would it be like going to a particularly stultified backwater in Europe where all they do is take care of their church and nobody actually worships there, but the tourists really enjoy it.

▶ BRIAN ENO:
He means London.
(laughter)

► **STEWART BRAND:**

I think this is a really valid fear. If we can keep everything, and we've got so much continuity that, you know, life is one big long Getty collection of precious old things, how the hell can you ever have an original thought under those circumstances without feeling just stupid, you know, up against these great masters, etc. I think part of keeping is throwing away. But part of managing the future is keeping options open. In families that are actually intact over periods of time there's the—you know, if they've got a house in the country that generation after generation use, up at the lake or something like that, they will get completely bored by the furniture of their parents, maybe their grandparents. But if there's a place to stash it, their children or their grandchildren will be absolutely delighted by that furniture. Because it will have gone out of fashion, back in fashion, be beyond fashion and so damn interesting in its own right.

So I think part of this kind of storage preservation can do at its best is free up the present from having to constantly refresh one's memory of, "Oh yeah, I think I care about this, I think I care about this." And that is past overload. So if this technology gets comfortable with the long term we can free it from the immediate past overload and give us the option for lots of past reaching if we want to. We can burn our own personal bridges and be creative—confident that society's bridges and civilization's bridges have not been burnt.

► **PETER LYMAN:**

We've been in some sense motivated by a bunch of this in that sort of fear of loss. But there's tremendous opportunities that allow us in aggregate to do things never possible before. So if we were to collect these things together, say the Library of Alexandria was not just new because it made copies of all the people's books of the world. It copied it in a place where people could study it all together. And do comparative things. Where you can detect the changes over time of what's going on the Internet and a way of doing an analysis and getting an understanding of what people are thinking about. There's a professor at Berkeley, a sociologist, who says in the archive, we have an unprecedented collection of human voices. Never before has such a collection been so easy to manipulate of what millions of people are thinking about. Maybe it's pictures of their dog, maybe it's pictures of their house, maybe it's junk, but it's stuff out there that we're now able to use. In a new form.

So I'd say what's motivating us is not just a fear of losing, but being able to build something new out of this digital rubble that we've created. To build something that's really quite amazing that may be as much of a landmark on our civilization as the Library of Alexandria was in the ancient world.

▶ **STEWART BRAND:**

This is not an immodest group. (Laughter)

We're at 4:30, so we'd like to call it a day here. Alexander Rose, Executive Director of The Long Now Foundation, took notes during the closed sessions on these flip chart sheets which you see along the walls here. You're invited to come down to the stage and peruse and wonder what they're about or . . . catch on to the hidden structure of what we're doing. Thank you all very much.

Ongoing Digital Dialogue : The
Time & Bits Threaded Discussion

(http://www.gii.getty.edu/timeandbits)

Shelley Z. Taylor

A Virtual Forum

The project team designed the Time & Bits Web site for two pur-
poses. First, it served as the primary means by which the project
participants could see a common set of information on this effort,
including background papers, suggested reading, biographies of
those involved, and the preparations and arrangements being
made for the conference. Second, it served as a locus for the initial
vetting of ideas, clarification of issues, and general inspiration. At
first, it was accessible only by the participants, and then just after
the New Year [1998], it was opened to anyone with professional
credentials and an interest in participating.

Since the conference in February, this Web site has taken on a
very interesting and populated life of its own. **Martin Diekhoff,** a
member of the team from the Information Institute, had con-
verted the e-mail discussion among the participants to a threaded
discussion for our larger forum, and organized it by theme. It now
involves people from around the world. The discussion ranges
broadly, from the technological to the institutional, from the realis-
tic to the fantastic. Several themes stand out in the dialogue about
creative solutions to the massive problem of long-term digital
preservation:

- the need for a universal translator
- who should manage digital continuity
- what information to preserve, and
- how to best preserve digital information.

Stewart Brand started things rolling with a call for designs for
a "universal translator"—an idea that had come to him in a
dream. He saw it as a mechanism that would work through soft-
ware and system improvements to convert documents continually
to new formats as needed, thus lengthening their lives.

Skeptically, **Brian Eno** pondered a future where all technolo-
gies were transparent and translatable. For his first video show in

Europe, he attempted to transfer his tapes from PAL format to NTSC format. The transfer didn't work; minutes before he was to cancel the program, he found some NTSC players and monitors for the show. Ever since, **Brian** has produced tapes in the format in which they would be shown. He said his "experience as an artist is that nothing ever translates unchanged into anything else." He now keeps the necessary equipment for 28 different storage formats in his studio.

Jaron Lanier added that with interactive media the problem is even worse. Not long ago, **Jaron** needed to reconstruct and make usable his art video game "Moon Dust" for a museum exhibition. Even though the hardware he needed was only 12 years old, several changes in the technology prohibited the operation of the program.

Brewster Kahle described a three-step solution to "the format problem"—specifically in cases where it is simply the data that needs saving. First, collect lots of important public documents in the target formats. Then, make the documents very accessible so that everybody can have them. Third, collect, catalog, and archive all programs and annotations dealing with these formats as people write translators and emulators. Make everything public.

Lanier noted that this might be true for simple documents, but that the way to keep interactive documents alive might be to keep them in perpetual use. He cited the Hebrew Torah as a historical and cultural example of a document kept alive and accessible because it has continually been copied and annotated—and valued.

Inspired by such musings on perpetual life, **Kevin Kelly** wondered if it would be possible to devise a formula to calculate the probable life expectancy of a document. **Lanier** posited differing life expectancies for various types of documents. He reiterated that non-interactive documents are probably in greater danger of extinction due to false social expectations that they will survive technological evolution.

Who Should Steward the Process of Ensuring Digital Continuity?

Brewster's three-step proposal led **Stewart** to wonder which institutions would be responsible for managing the process of digital continuity. **Esther Dyson** replied "that institutions appoint themselves [and] manage to get people to believe in them." How many institutions would be needed, and what attributes would those institutions need to have? **Brewster** liked the idea that a few

entities might steward the process of digital continuity, and came up with attributes of ideal managing institutions:

- integrated enough to get help and shielding
- technical enough to deal with terabytes
- culturally aware enough to make the collection worthwhile
- rich enough to deliver and continue
- chutzpah enough to try
- fun enough to work in

Is it wise, however, to think of preservation as a centralized function? **Gary Frost,** a library conservator, asked this question, and others agreed that one must allow for and encourage preservation in a way that is not centralized as well. **Gary** continued— "We are in a transition zone where every participant is needed. And not just in preservation activity, but also in the generation, duplication, and distribution of content—the projection of meaning—that preservation may morph into."

What Information Do We Preserve?

The question of what to preserve generated much discussion, and distracted many of those involved. In a closed session of the Time & Bits meeting, the participants tossed around the idea of a "Golden Canon." **Stewart Brand** reiterated the definition of the Golden Canon: "We imagined a digital canon, say of the great books. Call the slow version the 'Golden Canon.' Once collected and made fairly perfect, it is inscribed on an extremely durable medium. Call the fast version the 'Living Canon.' The latter invites intense and constant use, thus diligently kept up from platform to platform and version to version and medium to medium. If that chain of use is ever broken—inadvertently or through disuse—it can be rebooted from the Golden Canon with only a little difficulty. If users feel that important discontinuity has been introduced in the Living Canon incrementally over time, there is a 'pure' Golden version available for comparison."

This prompted Professor **Luciana Duranti** of the University of British Columbia to ask, "Why in the world would you wish to preserve in digital form the 10,000 most important texts? If they are electronic texts, that is documents having a paper analogue, why wouldn't people have them on paper? If they were generated on paper in the first place, why would one want to spend money digitizing them and maintaining them in electronic form? If they are books that require sequential reading, why would one want to read them on a screen? If they are so important and therefore well known and rarely accessed, why should one feel the pressure to copy them over and over?"

Robert Spindler, Head of the Department of Archives and Manuscripts, Arizona State University Libraries, agreed with Duranti that in preserving content, one should not focus on text documents more easily preserved—but multimedia or compound documents.

Tom Ditto posed a question that illustrates the complexity of the "what to preserve" issue. He wanted to know what would be done if one wanted to save a piece of music in digital form. Would one save the artist's recording of the music, the score, or both? How many different formats and versions of a digital object should we attempt to preserve? When does cost become a primary consideration? What in this case is the "original" document—and does it matter? After what point does an artist's right to alter or remove the work from distribution expire? The Golden Canon idea attracted **Michael Hart,** who is involved with Project Gutenberg, an initiative racing to put 2,000 important books on the Web by the year 2000. He warned that copyright might soon be extended to 95 years. This caveat prompted a considerable and ongoing discussion concerning copyright law and the impact of pending legislation on digital products and continuity.

How Do We Preserve Digital Information?

Both within the context of the discussion of the Golden Canon, and in the discussion generally, the issue of how best to preserve digital information resurfaced continually. Correspondents discussed the financial and technological needs of long-term preservation (bigger, more enduring storage platforms; more flexible and longer-lasting media; emulator research); the need for institutional and disciplinary guidelines, policies, and metadata standards; and a fascinating discussion on the applicability of laws of natural selection to information. **Martin Greenberger,** Professor at the Anderson School of Business at UCLA, announcing a lecture by Manfred Eigen, Nobel Laureate in Chemistry, triggered several correspondents to consider the application of evolution theory to information longevity. **Greenberger** wrote, "I am struck in the Time & Bits context by Eigen's observation that 'Information—unlike energy—is not subject to a conservation law,' and am intrigued by the idea that Darwinian evolution and the theory of entropy might be useful metaphors for the problem of digital continuity, even at the risk of joining those whose propositions border on the fanciful." The natural selection theme meshed at times with messages drawn from **Michael Lesk's** observation that "in the future, preservation will mean copying, not maintenance of an artifact." Several correspondents agreed that preservation must be rooted in reproduction and distribution activities.

Tom Ditto admitted to indulging in a sci-fi mind game when he proposed engineering a DNA-like self-duplicating mechanism that would allow information to replicate itself. Nevertheless, he, like others, believed firmly that copying was at the heart of preservation: "Copying has been the method by which most records are passed on from epoch to epoch, and the dynamic of making copies must be a part of the discussion."

There is room for the fantastic as well in the Time & Bits threaded discussion. Science fiction author **Bruce Sterling** wrote, "I'm surprised no one has suggested parking massive tiny archives in orbit. They'd make a nice reward for the next spacefaring civilization if they achieved escape velocity and discovered the complete works of the ancient Greeks." **Stewart Brand** got on board with his own fantasy: "Humans arrive on Mars and find a very, very old Clock [The Long Now's Clock Library], still ticking. That gets us looking for the archives." Creative solutions, indeed.

The Time and Bits Web site is still accepting applications from prospective discussants.

Afterword

Digital technology these days operates at the pace of months, while civilization and culture operate at the pace of centuries. That is a lethal mismatch, because digital technology is busy taking over civilization and culture and subverting their crucial longevity. Culture cannot remain passive against that threat.

The first "Time & Bits" meeting was framed the right way physically. Archivists and museum curators did not travel to Silicon Valley to beg for help from distracted technophiles. Instead, an array of high-tech leaders came to the Getty Center to engage its cultural treasures and the preservation issues of an ambitious new arts complex with a global constituency. In figure-ground terms, high-tech was figure, culture was ground. That's the way it should always be.

The digital talent for short-term solutions was understood as itself a profound long-term problem. Fixing the problem cannot be done by cultural players alone, since they need technical innovations, nor by high-tech people alone, since their world lavishly rewards immediacy rather than continuity. Happily, each group is titillated by the other's tools and issues, so the prospects are good for periodic collaboration.

Digital continuity is not just an "interesting" problem, it's a deeply tough one, and one whose gravity is growing every year. It has to be solved.

Stewart Brand
Founder
The Long Now Foundation

References

Australian Archives. "Managing Electronic Records—A Shared Responsibility." *Time & Bits Web Site*.

Bearman, David and Jennifer Trant. "Electronic Records Research Working Meeting May 28–30, 1997: A Report from the Archives Community." *Bulletin of the American Society for Information Science* 1998: 13.

Commission on Preservation and Access. *Preserving Digital Information: The Report of the Task Force on Archiving of Digital Information*.

Hamilton, William D. *Narrow Roads of Gene Land: The Collected Papers of W. D. Hamilton: Evolution of Social Behaviour*. London: W.H. Freeman & Co. 1996.

Kahle, Brewster. "Preserving the Internet." *Scientific American* March 1997: 82–83.

Lesk, Michael. "Preserving Digital Objects: Recurrent Needs and Challenges." *Time & Bits Web Site*.

National Library of Australia, National Preservation Office. "Statement of Principles: Preservation of and Long-Term Access to Australian Digital Objects." *Time & Bits Web Site*.

Rothenberg, Jeff. "Ensuring the Longevity of Digital Documents." *Scientific American* January 1995: 24–29.

Sanders, Terry. *Into the Future: On the Preservation of Knowledge in the Electronic Age* 16 mm, 60 min. 1997. Distributed by The American Film Foundation, Santa Monica, California.

———. *Slow Fires: On the Preservation of the Human Record* 16 mm, 60 min. 1987. Distributed by The American Film Foundation, Santa Monica, California.

Society of American Archivists. "Statement on the Preservation of Digitized Reproductions." June 1997. *Time & Bits Web Site*.

Sterling, Bruce. *Holy Fire*. New York: Bantam Books, 1997.

Time and Bits Press Coverage

Kaplan, Karen. "A Vision for the Past." *Los Angeles Times* 16 February 1998: D 1.

———. "The Culture's Immortal, but Not the Disk." *Los Angeles Times* 16 February 1998: D 1.

———. "Highlights of the Getty's Online Offerings." *Los Angeles Times* 16 February 1998: D 6.

Meloan, Steve. "No Way to Run a Culture." *Wired News* 13 February 1998. Online.

Tangley, Laura. "Whoops, There Goes Another CD-Rom." *U.S. News & World Report* 16 February 1998: 67–68.

Pierce, Anne. "Culture and Technological Obsolescence." *Wired News* 6 February 1998. Online.

Manes, Stephen. "Time and Technology Threaten Digital Archives." *New York Times* 7 April 1998: 4.

Gleick, James. "The Digital Attic: An Archive of Everything." *New York Times Magazine* 12 April 1998: 20–22.

Manes, Stephen. ". . . But With Luck and Diligence, Treasure-Troves of Data Can Be Preserved." *New York Times* 7 April 1998: 4.

Morrison, Philip and Phylis Morrison. "Wonders." *Scientific American* July 1998: 115–117.

Stepanek, Marcia. "Data Storage: From Digits to Dust." *Business Week* 20 April 1998: 128–130.

Digital Preservation Resources
on the Internet

These links were active as of July 1998, and accessible through the project Web site
(http:www.gii.getty.edu/timeandbits)

Clearinghouses, Resources, and Bibliographies

Conservation OnLine [http://palimpsest.stanford.edu/]
CoOL, a project of the Preservation Department of Stanford University Libraries, is a full-text library of conservation information, covering a wide spectrum of topics of interest to those involved with the conservation of library, archives, and museum materials.

Digital Library Resources & Projects [http://lcweb.loc.gov/loc/ndlf/]
A Library of Congress Internet Resource Page— Search digital libraries and related sources, access e-zines and e-discussions, government projects, university digital libraries and projects, conferences, and workshops.

Electronic Collections & Services [http://www.nlc-bnc.ca/ifla/II/]
International Federation of Library Associations and Institutions' network of resources, including a bibliography of books and periodicals; listing of conferences, organizations and worldwide projects relating to digital preservation and archives.

Preservation Format [http://info.wgbh.org/upf/]
This site disseminates information about the proposed universal preservation format for the archiving of digital media assets. One of the links on the site is the Needs Assessment Survey, devised to assist in incorporating the needs of potential users into a platform-independent preservation format.

Web Standards Project [www.webstandards.org]
This site discusses and outlines cross-platform browser compatibility issues, and provides standards information and advocacy for developers and consumers of digital culture and information resources on the Web.

Papers and Publications

Preserving Digital Information [http://www.rlg.org/ArchTF/tfadi.index.htm]
Report of the Task Force on Archiving of Digital Information.

Society of American Archivists [SAA] Statement on the Preservation of Digitized Reproductions. [http://www.archivists.org/governance/resolutions/digitize.html]
A statement of approved principles, many of which are relevant to the concerns of a UPF.

Toward A Universal Data Format for the Preservation of Media [http://info.wgbh.org/upf/SMPTE_UPF_paper.html]
This discussion is aimed at prompting industry exchange regarding technology that could be used in building a UPF.

Long Term Intellectual Preservation [http://aultnis.rutgers.edu/texts/dps.html]
Discusses the impact and relationship of electronic information and its preservation on "intellectual preservation" or authenticity.

Digital Preservation: A Time Bomb for Digital Libraries [http://www.uky.edu/~kiernan/DL/hedstrom.html]
Discusses digital preservation requirements, limitations of current preservation strategies, storage media, migration, conversion, management tools, and more.

Archivists Warn: Don't Depend on Digital Tape [http://www.connact.com/~eaw/minidisc/dat_archiving.html]
A group of the world's leading audio preservationists have warned that taped-based recording media— especially DAT—is not reliable for long-term preservation.

Requirements for the Digital Research Library [http://aultnis.rutgers.edu/texts/DRC.html]

Discusses issues archivists and librarians must face in conceptualizing a digital library.

Preserving Digital Objects: Recurrent Needs & Challenges [http://community.bellcore.com/lesk/auspres/aus.html]

A discussion of several problems posed to digital preservation, including multiple platforms and formats, life expectancy of various media, problems of conversion, standardization.

A Framework for Distributed Digital Object Services [http://www.cnri.reston.va.us/home/cstr/arch/k-w.html]

Discusses the basic elements of an infrastructure that supports an extensible class of distributed digital information services, specifically those elements which are intended to constitute a minimal set of requirements and services that must be in place to realize the infrastructure of a universal, open, wide area digital infrastructure system.

The Challenge of Archiving Digital Information [http://www.rlg.org/ArchTF/chaleng.html]

This discussion contests some of the commonly accepted solutions to the problem of digital preservation and establishes the framework from which the Task Force on the Archiving of Digital Information began.

Selecting Materials for Digital Preservation [http://www.duke.edu/~sdmiller/archives/select.html]

A discussion of what to preserve, part of a paper entitled "Manuscripts & Archives in the Digital Age." Author has also prepared a bibliography.

Future Directions in Access and Preservation Technologies and New Electronic Formats [http://www.nla.gov.au/nla/staffpaper/cwebb3.html]

An overview of recent technological developments which assist in providing access to and protecting original materials and the challenges posed by preservation in new electronic formats.

Preserving the Internet [http://www.sciam.com/0397issue/0397kahle.html]

Manuscripts from the Library of Alexandria in ancient Egypt disappeared in a fire. The early printed books decayed into unrecognizable shreds. Many of the oldest cinematic films were recycled for their silver content. Unfortunately, history may repeat itself in the evolution of the Internet—and its World Wide Web.

D-Lib Magazine [http://www.dlib.org/]

A digital library research project offering monthly features, commentary and briefings; a collection of resources for digital library research; and access to D-Lib's Working Groups.

Institutional Initiatives and Digitial Preservation Studies

Preservation of Multimedia Materials [http://scow.gseis.ucla.edu/faculty/mcloonan/html/287.htm]

UCLA Department of Library and Information Science course introducing students to the technical, managerial, and sociocultural issues related to the preservation of multimedia materials.

Universal Preservation Format [http://info.wgbh.org/upf/]

This site disseminates information about the proposed universal preservation format for the archiving of digital media assets. One of the links on the site is the UPF Needs Assessment Survey, devised to assist in incorporating the needs of potential users into the platform-independent UPF.

Corporation for National Research Initiatives [CNRI] [http://www.cnri.reston.va.us/]

Nonprofit organization that fosters and promotes research and development for the National Information Infrastructure. Activities center around strategic development of network-based information technologies. Publishes D-Lib Magazine, the magazine of digital library research, which offers monthly features, commentary and briefings; a collection of resources for digital library research; and access to D-Lib's Working Groups.

National Media Laboratory [http://www.nml.org/AboutNTA/AboutNML/]

The National Media Laboratory (NML) is an industry resource supporting the U.S. Government in the evaluation, development, and deployment of advanced storage media and systems. NML endeavors to provide a broad perspective of current progress in information technology issues, both from a commercial and a government perspective.

Center for Intelligent Information Retrieval [CIIR] [http://ciir.cs.umass.edu/info/ciirinfo.html]

Supports the emerging information infrastructure for the next century, through both research and technology transfer. Goal is to develop tools that provide effective and efficient access to large, heterogeneous, distributed text and multimedia databases. Focus is on software that will support accurate and efficient access to, and analysis of, the information stored in text and multimedia databases throughout government and business.

Harvard Information Infrastructure Project [http://www.ksg.harvard.edu/iip/]

A forum for addressing a wide range of emerging policy issues relating to information infrastructure, its development, use, and growth.

Information Infrastructure Task Force [http://www.pang.com/projects/iitf_html/index-t.html]

Formed by the White House to articulate and implement the Administration's vision for the National Information Infrastructure (NII).

UIUC Digital Library Initiative [http://dli.grainger.uiuc.edu/default.htm]

A project of the University of Illinois at Urbana–Champaign designed to be a testbed of scientific literature and researching device for enhanced search technology.

UC Berkeley Digital Library Project [http://elib.cs.berkeley.edu/]

A collaborative project aimed at developing technologies for intelligent access to massive, distributed collections of photographs, satellite images, maps, full-text documents, and "multivalent" documents.

The Informedia Project [http://www.informedia.cs.cmu.edu/]

A research initiative at Carnegie Mellon University seeking to resolve how multimedia digital libraries can be studied and used.

The Alexandria Project [http://alexandria.sdc.ucsb.edu/]

A consortium of multidisciplinary, public and private sector specialists exploring a variety of problems related to distributing a digital library for geographically referenced information.

Stanford Digital Libraries Project [http://walrus.stanford.edu/diglib/]

A collection of computing literature. This initiative is largely concerned with interoperability.

Digital Library Related Information & Resources [http://interspace.grainger.uiuc.edu/~bgross/digital-libraries.html]

The motherboard of the six Digital Library Projects with information on conferences, organizations, and publications.

Managing Electronic Records [http://www.aa.gov.au/AA_WWW/AA_Issues/ManagingER.html]

The Australian Commonwealth's efforts in preserving government and public documents through strategic management of electronic records; development and implementation of electronic record-keeping systems; and migration of electronic records, with their content, structure, and context intact, across changes in software and hardware platforms.

Social Effects of Information Technology

Howard Besser, UC Berkeley School of Information Management & Systems, Berkeley Multimedia Research Center, etc. [http://www.sims.berkeley.edu/~howard/]

Primary focus areas: Multimedia Databases, Social Effects of Information Technology, New Ways to Teach Technology.

Shaping Our Communities: The Impact of Information Technology [http://www.internetcenter.state.mn.us/ltn-open.htm]

Dedicated to expressing and exploring viewpoints regarding the impact of information technology on cities and towns.

Information Technology and International Affairs [http://library.lib.binghamton.edu/subjects/polsci/infotech.html]

Discusses the impact of advanced technology on international relations; includes international treaties on information technology, reports, etc.

The Center for Social Informatics [http://www-slis.lib.
indiana.edu/CSI/]

A program of the University of Indiana dedicated to
supporting research into information technology and
social change.

Risks and Hazards

**Comprehensive History of Viruses [http://csrc.ncsl.
nist.gov/nistir/threats/subsubsection3_3_1_1.html]**

The NIST [National Institute of Standards and Tech-
nology] assessment of the history of "malicious
code" (viruses and worms) includes a discussion of
"malicious code," summarizes protection methods
and projects future threats from both malicious code
and human attack.

**The Risks Digest: Forum on Risks to the Public in
Computers and Related Systems [http://catless.ncl.
ac.uk/Risks/]**

An ongoing, open forum on risks to the public of
computers and related systems. The forum began in
1985. Its primary concern is whether critical require-
ments for human safety, system reliability, fault
tolerance, security, privacy, integrity, and guaranteed
service can be met within the industry and how
attempted fulfillment or ignorance of these require-
ments may imply risks in the future. To participate in
the Risks-Forum online discussion, click here.

The Year 2000 [http://www.year2000.com]

Information, issues, discussion, and solutions for the
"Y2K" problem, an impending issue of critical
importance for all databases containing date infor-
mation as 2-digit years give way to 4-digit at the
turn of the millennium.

Data Storage

**Mass Storage Based Solutions for Digital Media
Archives [http://www.nbr.no/fiat/Bogensee/
2-156stark.html]**

A discussion of the four major functional compo-
nents of a digital media archive.

**National Synchronization [http://dli.grainger.uiuc.edu/
national.htm]**

Initiative driven to advance the means to store,
collect, and organize information in digital forms
such that it is easily accessible and user-friendly.

**Storing the Web [http://www.techweb.com/se/
directlink.cgi?INW19971013S0044]**

Alexa Internet, a free Web navigation service, stores
all the daily contents of the Web, tracks sites visited
by Internet users, and grades the value of a site
based on a series of customized benchmarks. Alexa
also generates statistics on variables such as how
frequently sites are updated and how often linked
sites are accessed. Through Alexa, users can access
sites that are no longer displayed. In other words, if it
has appeared on the Web, Alexa has it.

**IDAM [http://www.monmouth.edu/monmouth/
academic/dna/w3cf.html]**

Proposal for an active document archive manage-
ment system which seeks to customize available
technologies to bridge the worlds of existing proto-
cols and tools and thereby control and manage
information in the digital universe.

Data Security

**IT Security and Recovery Survey [http://www.
techweb.com/se/directlink.cgi?IWK19970908S0045]**

The Fifth Annual Information Week/Ernst & Young
Information Security Survey points to a growing
awareness, concern, and difficulty with data security
problems, largely attributed to the Internet. Many
companies are boosting internal IT security staff to
handle reported increases in the following data
security categories: [internal] security breaches;
system vulnerability; viruses and human attack.

**Internet Security [http://www.beyondhype.com/
security1/index.htm]**

A general presentation of the problem.

Digital Resources & Repositories

The Internet Archive [http://www.archive.org/]

A collection of public materials and downloadable
software from the Internet.

The Research Libraries Group [http://www.rlg.org/]

A nonprofit corporation devoted to "improving
access to information that supports research and
learning." Link offers an extensive bibliographic
database, Web and print publications and related
specialized services.

The Retrocomputing Museum [http:www.pdc.kth.se/
~jas/retro/retromuseum.html]
> An online archive / museum dedicated to the task of
> collecting programming languages, early personal
> computer emulators, and their software.

Library of Congress [http://lcweb.loc.gov/]
> The online database.

Hooking Legacy Mainframes to the Web [http://www.
techweb.com/se/directlink.cgi?IWK19970526S0052]
> Oracle has recently licensed software which it will
> integrate with the Oracle Web Application. The new
> software provides secure connections to legacy appli-
> cations using Java applets. This will allow companies
> to preserve their investment in legacy systems while
> taking advantage of the latest Web technologies.

Berkeley Digital Library SunSITE
[http://www.sunsite.berkeley.edu/]
> Do you want to build your own digital library? For
> digital library services, information, and support.

Digital Obsessions [http://www.hotwired.com/wired/
5.02/esgutenberg.html]
> What kind of a man wants to put the 10,000 most
> important books online by 2002 and make them
> available for free? (Hint: the kind of man who puts
> sugar on his pizza.)

Meetings, Conferences, and Events

The RSA Annual Data Security Conference [Jan. 13–18,
1998] [http://www.rsa.com/conf98/html/index2.html]
> Called the "sine-qua-non event of the crypto
> community," this conference brings together cryp-
> tographers, policymakers, business people, and
> technology developers on Nob Hill for four days of
> the latest trends in research, product development,
> market analysis, and social thought in the field of
> cryptography.

Report of the Santa Fe Planning Workshop on
Distributed Work Environments: Digital Libraries
[http://www.si.umich.edu/SantaFe/]
> Report on workshop aimed at transcending current
> notions of digital libraries.

DRAFT Document from the RLG [http://lyra.rlg.org/
preserv/digarch1.html]
> RLG Preservation Working Group on Digital Archiv-
> ing Progress Report from May 1997 meeting.

Preservation in the Digital Age: Whether To, What To,
How To [http://www.carl-acrl.org/Archive/
Conference95/preservation.sum.html]
> A summary of the panel discussion from the Third
> Annual Conference of the California Academic and
> Research Libraries.

The monuments of wit and learning are more durable than the monuments of power or of hands. For have not the verses of Homer continued twenty-five hundred years or more without the loss of a syllable or a letter, during which time infinite palaces, temples, castles, cities have been decayed and demolished?
FRANCIS BACON

http://www.longnow.com/10klibrary/TimeBitsDisc/index.html